IMAGES
of America

LEESBURG

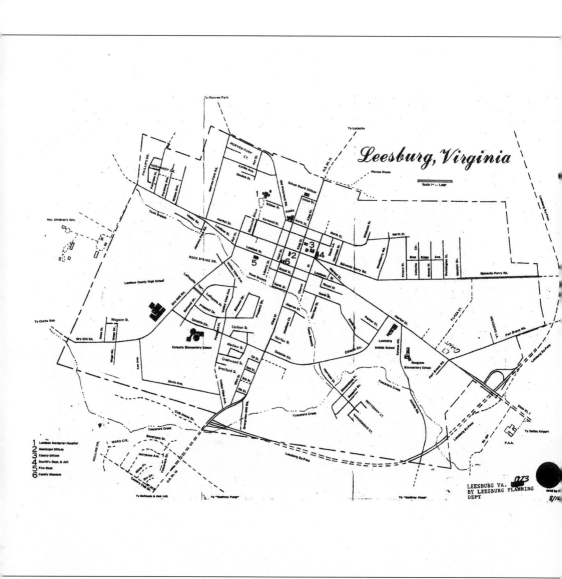

This basic street map of Leesburg was drafted in 1973 by the Leesburg Planning Department.

IMAGES
of America

LEESBURG

Mary Fishback

ARCADIA
PUBLISHING

Published by Arcadia Publishing
Charleston, South Carolina

Printed in the United States of America

Library of Congress Catalog Card Number: 2003104549

For all general information contact Arcadia Publishing at:
Telephone 843-853-2070
Fax 843-853-0044
E-Mail sales@arcadiapublishing.com
For customer service and orders:
Toll-Free 1-888-313-2665

Visit us on the Internet at www.arcadiapublishing.com

This book is dedicated to all the past generations of the people of the town of Leesburg whose planning and foresight have ensured the preservation of historic Leesburg and to those who will continue to shape the future of this truly unique town.

CONTENTS

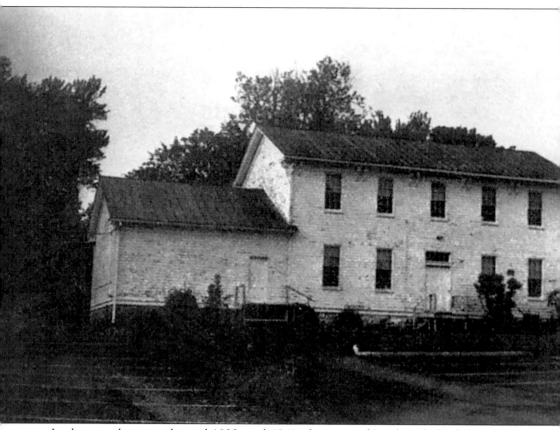

In the years between the mid-1920s and 1941, the town of Leesburg helped the community erect several school buildings for the African-American population. Loudoun High School (top) was built in the 1920s and remains much in its original condition and is used by the Loudoun County School System as a storage facility. Douglass High School (bottom) was built in 1941 and named in honor of Frederick Douglass. The graduating class had the following four students: Mable Margaret Dozier, Alice Virginia Roberts, Raymond Claudius Hughes, and William McKinley Washington. The last class in Douglass High was in 1968 with 40 students graduating. Douglass alumni continue to have a strong voice in maintaining Douglass High School as part of the Douglass Community Center on Business Route 7. (Photograph courtesy Douglass Alumni Records, Balch Library.)

INTRODUCTION

Leesburg has one of the richest histories of any town in Virginia, and has played a major part in numerous historical events. Any attempts to document this vast history would be only a brief sketch of a few major events that occurred in the past 245 years. Obviously, photo documentation for the first 100 years of Leesburg history is non-existent and one must rely on sketches, paintings, and written accounts of that time. It is my desire to show the historical events that transpired in Leesburg that give it a unique place in the annals of American history. The collections of pictures offered in this book are varied in content and will give you a view of Leesburg that you may never see again. Some of the photographic collections were taken by locals like David Frye and Winslow Williams; others, like postcard collections, have been kept by various people over the past 100 years or so. This book is a community effort; some of the snapshots are simply family pictures while some are from professional photographers never before published. I do hope you enjoy the book and my humble attempt to show the history of a small town that has greatly influenced America's history.

Since the history of Leesburg is so vast it is also controversial. Leesburg was established in 1758 and is located at the intersection of two of the most traveled roads in Virginia, U.S. Route 15 and Route 7, and is located on the land of Nicholas Minor, the county's first land speculator. Originally called Georgetown in honor of the King of England, the town was renamed Leesburg and is believed to be named for Thomas Lee, the patriarch of the Lee family in Virginia.

Leesburg is the county seat for Loudoun County. It has been a safe haven for Washington, D.C.'s political figures and a "get away" for Washingtonians who found the summer heat and stench of the city too oppressive. The early history of Leesburg is very well documented. It was a major player in the Revolutionary War. In 1812, when the British threatened to burn Washington, Leesburg, a well-known town less than 60 miles away, was chosen as a safe place to house the nation's most precious documents. According to the diaries of the wagon master Mr. Pleasonton, the Articles of Confederation, the Declaration of Independence, and the Constitution were kept in Leesburg, thus making it the capital of the United States for about four days. Political figures such as George Washington and General Lafayette visited Leesburg, where Lafayette dined with President James Monroe at his home Oak Hill, about eight miles south of Leesburg.

During the Civil War, Leesburg was a strategic point for both the North and South and changed hands over 100 times. When the invasion of Maryland was being planned, the Harrison House on North King Street (Route 15) was chosen to be the meeting place for

Robert E. Lee, James Longstreet, Stonewall Jackson, and J.E.B. Stuart. After the Battle of Ball's Bluff in 1861 near Leesburg, many wounded troops were brought to a temporary hospital in the brick Methodist church located on Market Street and many other homes became makeshift medical stations for the less severely wounded. Many of these homes remain today.

In the years that followed the Civil War, Leesburg was getting deeper into politics and was recognized by Richmond and Washington, D.C. politicians alike. Gov. Westmoreland Davis, Sen. Harry Byrd, Eleanor Roosevelt, President Herbert Hoover, and Gen. George C. Marshall are just a few of the dignitaries who have visited Leesburg over the years. Marshall and Davis actually lived in or near Leesburg. Today, Leesburg enjoys celebrating its cultural and historical heritage with events like August Court Days and the Bluemont Concert Series. The Loudoun Museum and the Thomas Balch Library, combined with the colonial atmosphere of the downtown area and these events, give Leesburg a truly unique feel.

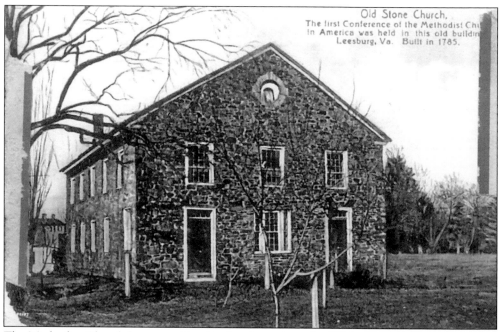

The Methodist Church has owned land in Leesburg since the 1700s. This postcard depicts the old church on Cornwall Street that was demolished in the early 1900s. The Old Stone Church Foundation maintains the graveyard, and it is the oldest Methodist-owned property in the United States.

One

LEESBURG
A BRIEF HISTORY

Leesburg was established in 1758 and was truly a small town with dirt streets and few businesses. The town was laid out surrounding an important crossroads for travelers and was organized by prominent men from Fairfax and Prince William Counties. Due to its convenient location, Leesburg was chosen as the county seat for the newly formed County of Loudoun. The town is noted for its rich heritage from the colonial era. Many of the homes in the "Leesburg Historic District" date back to the mid to late 1700s. These buildings have been modified over the years to accommodate and reflect the owners and the architecture of the times. Leesburg has a wonderful downtown area that retains the old-world charm of a bygone era.

Thousands of people have passed through Leesburg during its rich 250 years. This is just a brief overview of some of the more noted events and people who have visited and lived in Leesburg.

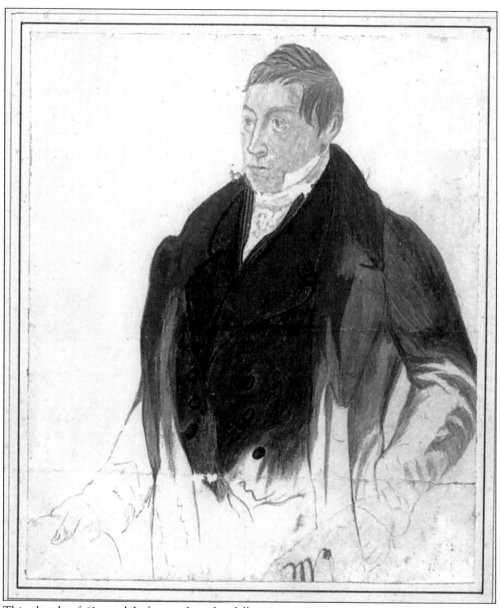

This sketch of General Lafayette has the following inscription written on the back: "This portrait of Lafayette was drawn by a lady on the occasion of his visit to Loudoun County Va." The sketch was the property of Judge L.P.W. Balch. This sketch is being conserved and will hang in the Thomas Balch Library, which is named in honor of Judge L.P.W. Balch's son. Lafayette visited Loudoun County on several occasions and there are news articles that tell how popular he was in Leesburg. He also visited President James Monroe and spent time at the President's home Oak Hill.

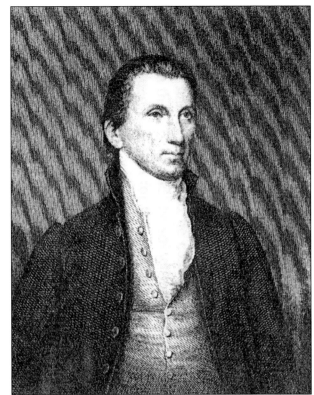

James Monroe (1758–1831) was the fifth president of the United States. He lived about eight miles south of Leesburg on U.S. Route 15 on his beloved estate Oak Hill, where Dolley Madison and Lafayette were often visitors. As a token of his esteem for Monroe, Lafayette gave him two matching chandeliers for the dining room and parlor of Oak Hill. James Monroe wrote the famed Monroe Doctrine in the parlor of Oak Hill, which was designed by James Hoban, the famed architect and designer of the White House. During the Civil War, Gen. George Meade used Oak Hill for his headquarters during the Battle of Bull Run. Today Oak Hill is privately owned and is a working farm. (Photograph courtesy Thomas Balch Library.)

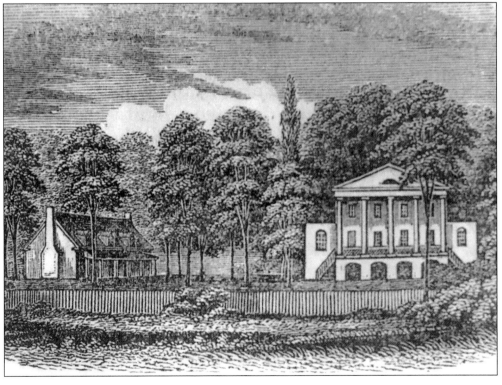

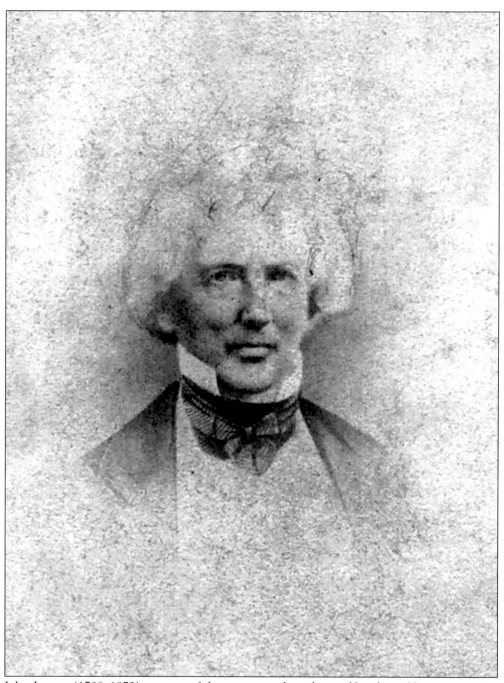

John Janney (1798–1872) was one of the more noted residents of Leesburg. He was a patriot, lawyer, and citizen leader. He gained notoriety as the person who handed Gen. Robert E. Lee his sword and commissioned him as the leader of the Confederate troops in Virginia. Janney achieved national prominence in 1861 as President of the Secession Convention. He was a Unionist but once the Convention voted to secede, John Janney went along, stating "Virginia is my destiny and with her I shall sink or swim." He survived the Civil War but never held public office again. John Janney's home is located on Cornwall Street in Leesburg.

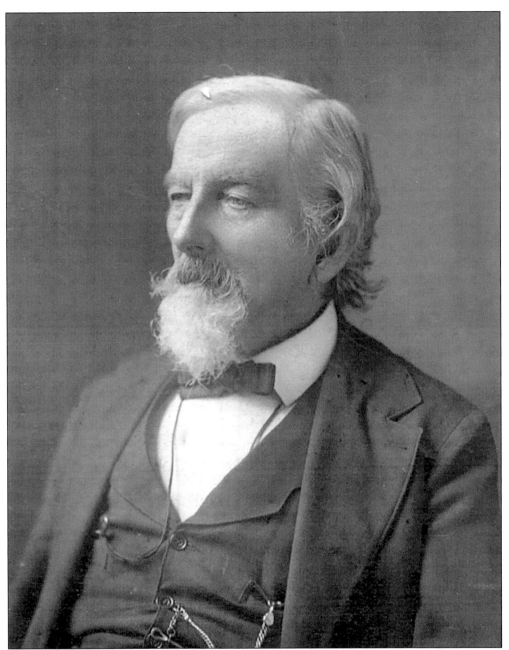

John M. Orr was the mayor of Leesburg during the Civil War. Leesburg changed hands many times from Union to Confederacy, but was never burned. Since there were no court proceedings in Leesburg and Records of the Court of Loudoun were not found, there was no need to burn or loot Leesburg. George K. Fox Jr. took the Loudoun County court records to Campbell County, Virginia. This saved the records from being burned as well as the courthouse and the town itself. Leesburg was one of the towns authorized to print money. Orr's name appears on those notes printed in Leesburg. (Photograph courtesy Balch Archives.)

Old St. James Episcopal Church on Church Street was built about 1812 and was demolished in 1895. On this old church site there remains a cemetery. The cemetery is the final resting place for such local historical figures as Armistead Thomson Mason, Horace Luckett, Burr William Harrison, Maj. William Noland, Thomas Swann, and several members of the Lee family.

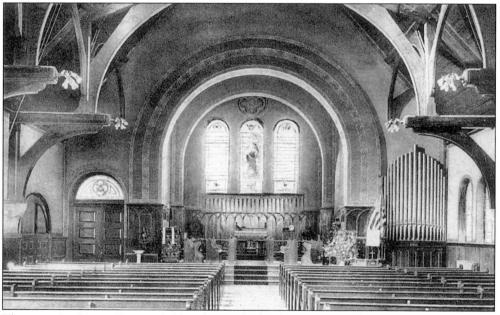

The new St. James Episcopal Church was built about 1895 and remains a landmark in Leesburg today.

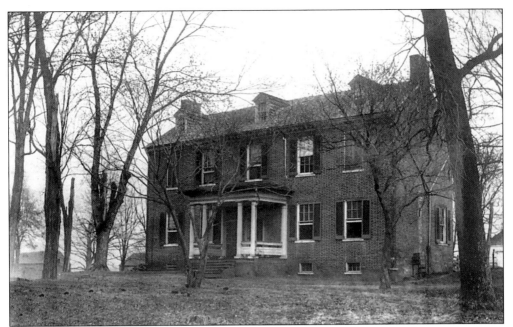

Rockland, a historic estate north of Leesburg on U.S. Route 15 (the old Carolina Road), originally contained 600 acres and was part of a land grant from King Charles to Lord Culpeper in about 1650. The house has played host to many families and has had a number of additions since it was built about 1822. Five generations of the Rust family of Loudoun County have lived at Rockland. The current owner is a descendant of Virginia House of Delegates member General George Rust, who is credited with building the house and at least one of the additions. In recent years Rockland has been on the Historic Gardens Tour. The gardens are extensive and beautifully maintained. The top photograph was taken of Rockland c. 1900. The bottom shows Rockland as it appears today. (Photograph courtesy Balch archives.)

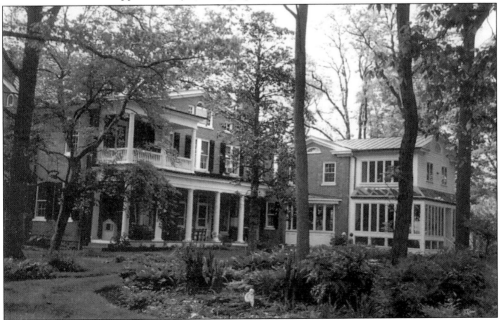

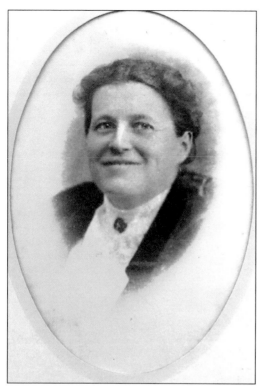

Lily Southgate Rust (left) was born at Rockland on February 9, 1866 to Armistead T. M. Rust and Ida Lee. She married Thomas Washington Edwards (below), who owned and operated Edwards Drug Store in downtown Leesburg. Lily and Thomas later bought the home of former Leesburg attorney John Janney (1798–1872). Their daughter Ida Lee Edwards, who married William Junkin Cox, later owned the house. Lily Southgate Rust Edwards died March 12, 1928. She and her husband are buried at Union Cemetery in Leesburg.

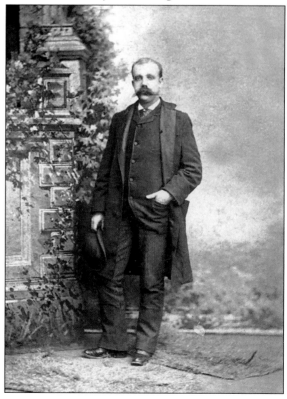

The house John Janney bought on Cornwall Street was built about 1780 and renovated in 1800 and 1830. James Monroe and General Lafayette were guests at the house and Robert E. Lee visited Janney there during the Civil War. As these two views show, the facade has changed several times with renovations and additions after a fire in 1940. The top photograph shows the porch as it was before a 1946 renovation. Lee Rust Edwards Cox, daughter of A.T.M. and Ida Lee Rust and a future owner of the house, is pictured on the right. The bottom photograph shows the porch much as it appears today. (Photographs courtesy Teckla Cox, owner.)

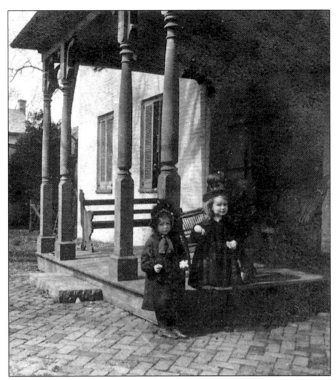

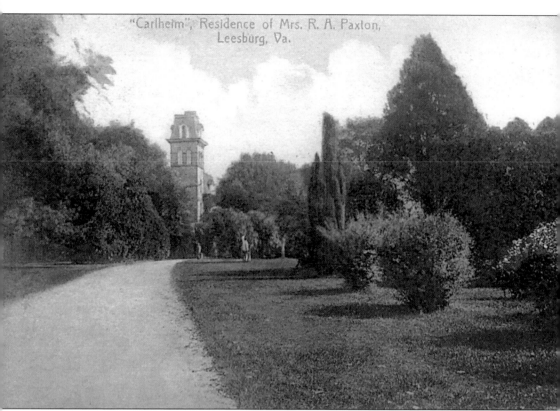

Carlheim is an estate that has transcended time. It was modeled from the plans of a German castle. Charles Paxton of New York bought the land around 1864. He built the beautiful estate that today sits within the town limits of Leesburg. Rachel A. Paxton, his widow, left the property as a memorial to her daughter Margaret in 1922. The property was in litigation until 1955, when it reopened as the Margaret Paxton Home for Convalescent Children. Known as Paxton Home in the 1960s and 1970s, it was a home for the care of orphans. In 1979 Carlheim was admitted to the Virginia Landmarks Registry of Homes. Today Carlheim is known as the Paxton Child Development Center. The postcard shows the house as it looked in the 1920s.

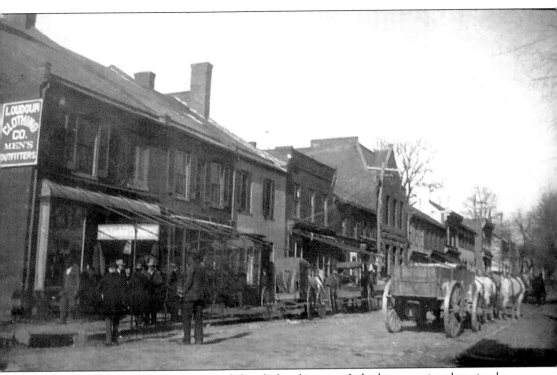

By 1900 Leesburg was a well-established, hustle-bustle town. It had proven its place in the annals of history. The shops were firmly rooted and a large hotel graced the north side of the courthouse lot. Travelers came by train from Washington, D.C. to shop, visit, and spend time with relatives. With daily mail service by train and a reputable newspaper since about 1800, Leesburg was flourishing. This early 1900s photograph shows the west side of King Street looking north. The third courthouse would be just to the right. Most of these buildings still stand and remain as businesses. (Photograph courtesy William C. Whitmore Jr.)

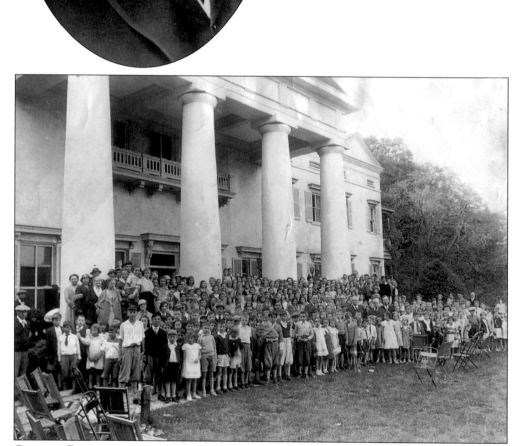

In the 1900s Leesburg was a political force in more than just Loudoun County. Leesburg's own Westmoreland Davis was elected governor of Virginia in 1918. He held that post until 1922. Davis owned the prestigious Morven Park, just two miles outside of Leesburg. He was the owner and publisher of the *Loudoun Times* and later the *Loudoun Times Mirror*, both local newspapers. He was instrumental in the publishing of the *Southern Planter*. Davis was a huntsman, agriculturist, and farmer.

Governor Davis was a generous man who entertained lavishly at his estate, Morven Park. This 1920s picture shows Loudoun school children visiting Morven Park for a day of fun.

The C.C. Saffer Brothers Mill ran for many years in Leesburg. It was located in the area of Leesburg known as the "wharf." It sold grain and feed to local farmers. Today the mill has been moved a short distance from the original site and houses an upscale restaurant, "Tuscarora Mills." The top photograph shows the Saffer brothers Claude C. and W. Clinton, c. 1936. In the background is the railroad station. (Photo courtesy Wynne C. Saffer.)

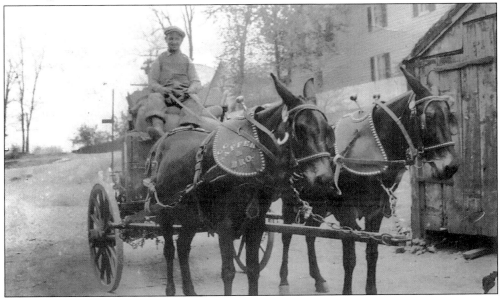

This photograph appeared in the *Loudoun Times Mirror* feature "Out of the Attic" in 1987 with the following caption: "Mules Jack and Jim with driver John Smith make a delivery of feed to the C.C. Saffer Mill at Leesburg in the 1930's." According to Clint Saffer, the mules were washed down the Potomac River in a flood, ending up at Saffers Mill without anyone knowing who the owners were. Smith plowed gardens around Leesburg and delivered feed to the mill with the help of these mules. (Photograph courtesy Wynne C. Saffer.)

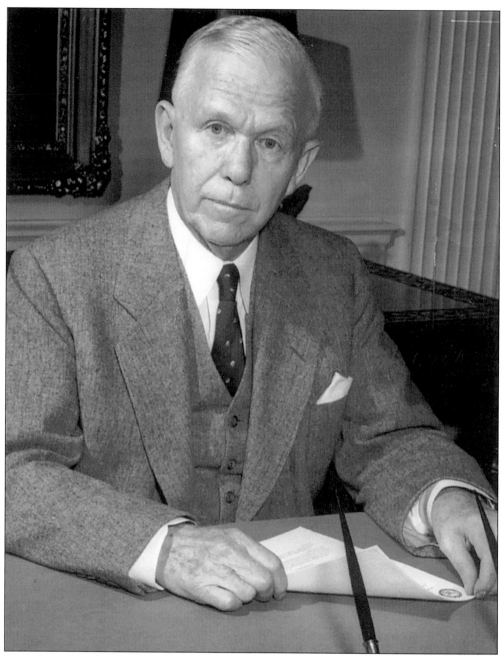

Gen. George Catlett Marshall (1880–1959) was a soldier, statesman, and the author of the Marshall Plan after World War II. General Marshall enjoyed the military but by the early 1940s was looking for a simpler way of life. General Marshall enjoyed vegetable gardening and his wife Catherine enjoyed flower gardening, especially roses.

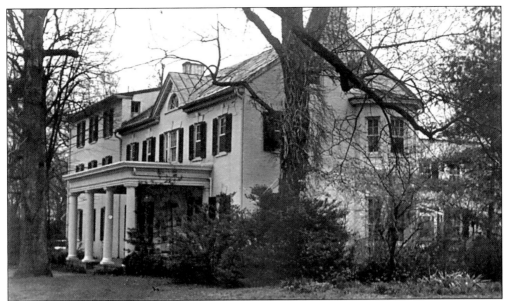

The Marshalls bought Dodona Manor in 1941. The house, now just two blocks from the historic downtown section of Leesburg, was built about 1786. George and Catherine Marshall became respected members of the Leesburg community where General Marshall was a member of the Catoctin Farmers Club, one of the oldest agricultural associations in the United States. He was also a member of the Leesburg Rotary Club and attended St. James Episcopal Church on Cornwall Street. This was the only home ever owned by the Marshalls and here they entertained many dignitaries, from heads of state to Presidents. President Truman would often come to see the Marshalls and was served tea in the beautiful gardens at Dodona Manor. Many people still remember seeing General Marshall walking about town talking with friends and neighbors. Leesburg was home to General Marshall until his death. Today Dodona Manor is being restored as a memorial to one of America's greatest men.

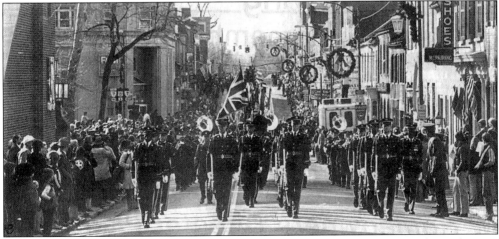

A statue to Gen. George C. Marshall was erected on the Loudoun County courthouse lawn in December 1980. The above view shows the commander of the troops leading an all-military parade in honor of General Marshall. Nearly 3,000 people came to Leesburg to see the parade and dedication of the statue. In 2000 the statue was removed for safe keeping during renovations. It is scheduled to return to the Court Complex upon completion of the work.

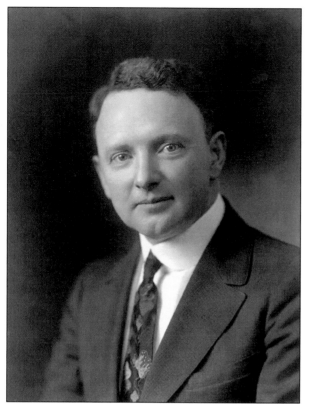

Harry Flood Byrd (1887–1966) was one of the most powerful men in the political scene of Virginia. He was governor of Virginia, Democratic Party leader, and United States Senator for over 30 years. The "Byrd Machine" was one of the most effective political alliances ever assembled in Virginia. The Byrd Machine was a group of conservative democrats who dominated Virginia elections as the state and local levels. Byrd loved Leesburg and came often to important political and social functions. The Loudoun Byrd headquarters was located on Route 15 South in downtown Leesburg. Byrd's wife, Ann Douglas Beverly (1887–1964) was born in Leesburg. Harry F. Byrd had four children.

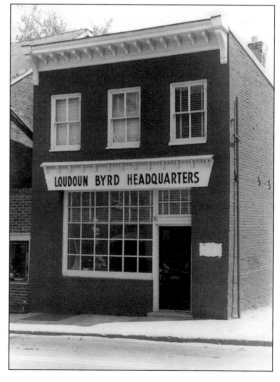

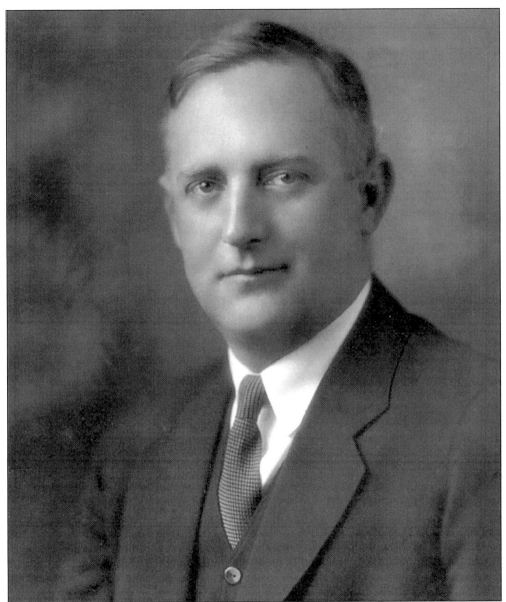

No history of Leesburg would be complete without a mention of Wilbur C. Hall. Born on February 5, 1892, he was the son of John W. and Annie E. Holliday Hall. He was admitted to the Virginia State Bar in 1915 and his practice was in Leesburg. His list of accomplishments is long. He was Chief Petty Officer of the United States Navy, member of the Virginia House of Delegates 1918–1935, Commissioner of Fisheries, a Mason, Odd Fellow, and Rotarian. His legislation helped create the Division of Motor Vehicles, which was responsible for ensuring that drunk driving was a criminal offense in Virginia. He was elected Citizen of the Year in 1967 by the *Loudoun Times Mirror* and was on the board of directors of Union Cemetery. It has been said that if it was happening in Leesburg, Wilbur Hall knew about it or had a part of it. Wilbur Hall died at the age of 80 in 1972. A well-respected citizen, he left over $1 million to Washington and Lee University and his collection of historical papers to Thomas Balch Library. (Photograph courtesy Balch Archives.)

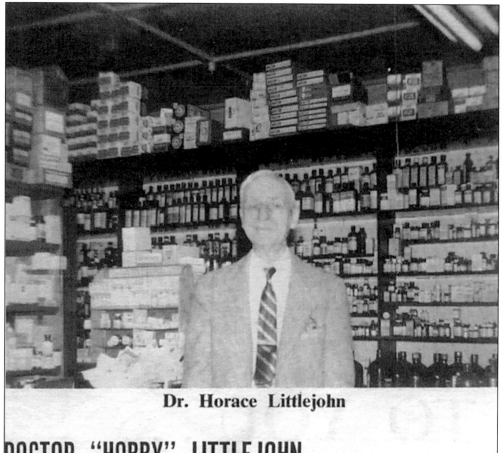

Dr. Horace Littlejohn

DOCTOR "HOBBY" LITTLEJOHN
— A Leesburg Institution
Loved by Leesburg

This photograph appeared in *Footings Magazine* in August 1961. It was a spotlight on one of Leesburg's older institutions. Dr. Horace "Hobby" Littlejohn was 79 years old in 1961. His soda counter and drug store are still remembered fondly by some of the older town residents. In 1900 Dr. Littlejohn's pay was $100 per year. With hard work he bought the small drug store of Mott and Purcell and opened his own business. Littlejohn's was the place to go for over 65 years. Some can remember when Cokes were 5¢ and so was ice cream! Dr. Littlejohn would tell interested listeners about his grandfather "Chambers," who was in charge of the Harpers Ferry Arsenal during the John Brown Raid. The story of Hobby Littlejohn is like so many institutions—they fade away in practice, but their legacy lives on.

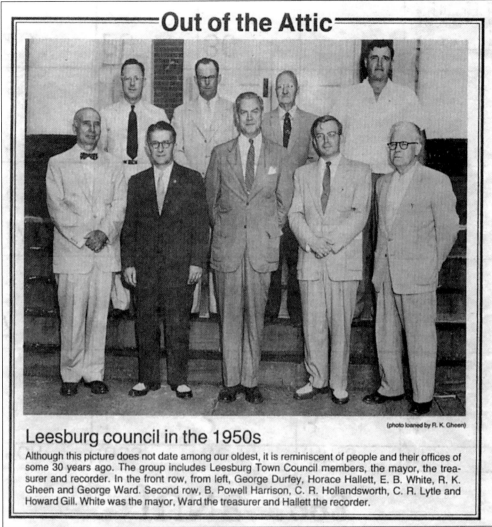

The *Loudoun Times Mirror*, a local Leesburg newspaper, has run a series called "Out of the Attic" for many years. This one shows the Leesburg town council in their formal photograph in the 1950s.

By CAROL CORNWELL
Zoning Administrator

WITH the adoption of a County Zoning Ordinance in 1942 by the Supervisors, Loudoun became the first predominantly agricultural county in the Commonwealth to be zoned. (The County ordinance has no jurisdiction within limits of incorporated towns.)

The ordinance divides the county into six separate districts as shown on a County Zoning Map. This map was prepared by an engineer from the State Planning Board, now known as the Division of Planning and Economic Development. These districts are: Highway Residential, Highway Agricultural, Highway Commercial, Village Residential, Village Commercial, and Rural. In each of these districts only certain uses are permitted.

The Highway Residential, Highway Agricultural and Highway Commercial Districts represent 200-feet strips along either side of the primary highways.

The Village Residential and Village Commercial Districts represent areas in four of the unincorporated towns. Three of these villages, located off primary highways, thought they needed more protection through zoning than was afforded by regulations in effect in the Rural District.

The Rural District represents all parts of the county not included in Highway and Village Districts. All uses not otherwise prohibited by law are permitted in the Rural District expecting a few uses (such as restaurants, tourist courts, trailer camps and abattoirs) which, though not necessarily objectionable in themselves, could be highly objectionable in a particular location.

(*Continued on page 22*)

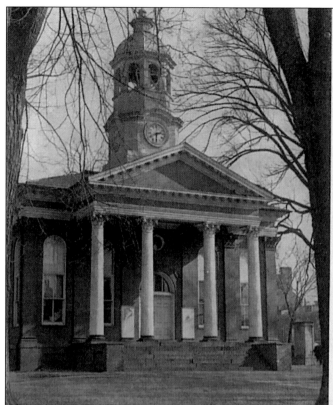

The Loudoun Court House Clock.
(Photo by Winslow Williams.)

RURAL ZONING

*Loudoun's Lovely Vistas
Freed of Ugly Signs*

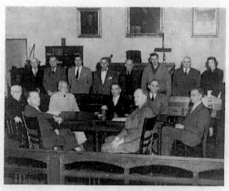

Loudoun County Officials are, seated, left to right: E. O. Russell, Clerk; J. Emory Kirkpatrick, Supervisor, Broad Run District; D. C. Sands, Supervisor, Mercer District; B. W. Mc-Kimmery, Supervisor, Leesburg District; J. T. Hirst, Superior, Mount Gilead District; H. C. Mock, Supervisor, Jefferson District; and I. W. Baker, chairman, Supervisor, Lovettsville District; Standing, O. L. Emerick, Superintendent of Schools; R. F. Nixon, Comissioner of Revenue; Stirling M. Harrison, Commonwealth Attorney; S. Reed Galleher, Treasurer; S. P. Alexander, Sheriff; John Heflin, Game Warden; J. M. Board, Resident Engineer; and Miss Carol Cornwell, Zoning Administrator. (Photo by Winslow Williams.)

This page was scanned from a 1949 magazine *Virginia and the Virginia County*. Loudoun County officials were concerned with zoning and commercial districts and the preservation of the area, much like today. As one of the fastest growing areas in Loudoun County, the preservation of Leesburg is a top priority. The courthouse shown in this photograph is the third at the same site in downtown Leesburg. It was built in 1894. The members of the board of supervisors change, but one has to wonder if the goals in 1949 are still the same goals the town has today. (Courtesy Jane Bogle.)

Two

MORE CURRENT
AFFAIRS

Since the 1950s Leesburg has experienced growing pains. Loudoun County was rapidly expanding and Leesburg, the county seat, had to grow with it. Land was annexed and new schools, parks, mini-, and outlet malls were built all around town. Historic preservation and renovation are hot topics in Leesburg today. In less than 60 years Leesburg has gone from one caution light at the intersection of Routes 7 and 15, to dozens of traffic lights. Traffic is grid locked in the morning and evening, fast food places compete with upscale restaurants, and family businesses compete with malls. Through all of this Leesburg has managed to find a happy medium where the past is merging with the present to create one of the most picturesque towns in Virginia. Maintaining this balance is a constant challenge. Strong political, social, and economic leaders are needed to keep pace with the growth and development in Leesburg and Loudoun County as a whole. Change and growth are keys to ensuring that the past, present, and future of Leesburg will remain a vital part of Virginia's history.

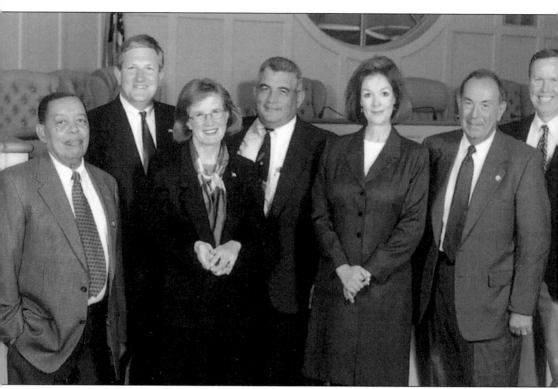

Here are leaders of the new millennium, the 2002 town council. Pictured from left to right are Mervin Jackson, David Schmidt, Mayor Kristen Umstattd, Fernando Martinez, Malinda Kramer, Robert Zoldos, and Frank Buttery.

This building was the town hall for many years. Located at the corner of King and Loudoun Streets, it was the old Leesburg Opera House before becoming the town hall. It also housed a variety of businesses before being demolished in the late 1950s. White's Department Store built a new building on the site that today houses an antiques mini-mall.

This David Frye photograph shows the town office building in 1971. Located behind the Tally-Ho Theater, this building served as the town office for about 20 years. Growth in Leesburg and overcrowding in the building led to the construction of a new town government center in 1989. (Photo by David Frye.)

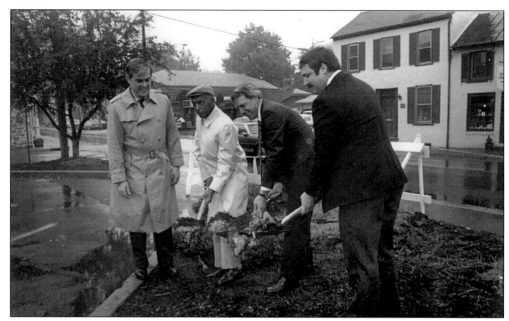

This photograph shows the groundbreaking ceremony for the present town hall on May 15, 1989. Present were Hanno Weber, council member John Tolbert, Mayor Sevila, and Ted Baker of the Manhattan Construction Company. (Photograph courtesy Town of Leesburg Archives, Nicole Ard.)

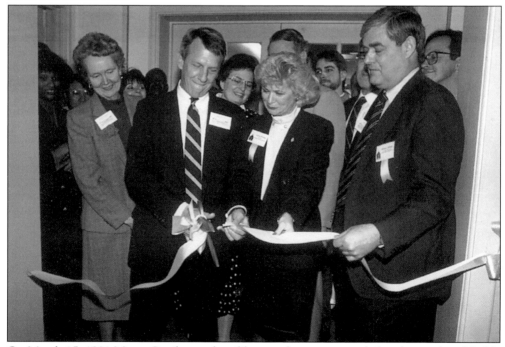

On March 15, 1991 Mayor Sevila cut the ribbon to the new council chambers at last. Visible with him are (from left to right) council members Georgia Bange and Christine Forrester, state delegate Linda Rollins, and architect Hanno Weber. (Photograph courtesy Town of Leesburg archives.)

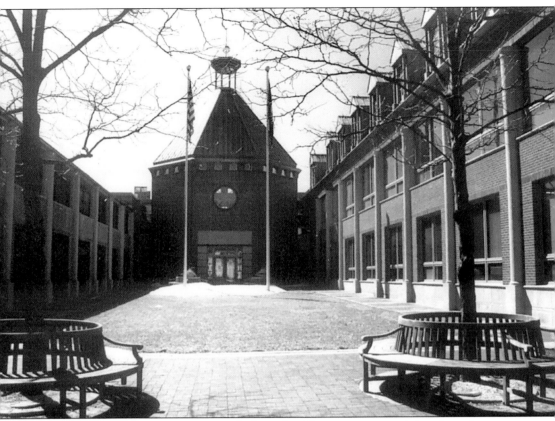

This is the town government center as it looks today. There are many mini parks and green areas located around town. This building houses the town council chambers and most of the offices for the day-to-day business activities of the town. (Photograph by Fran Poston.)

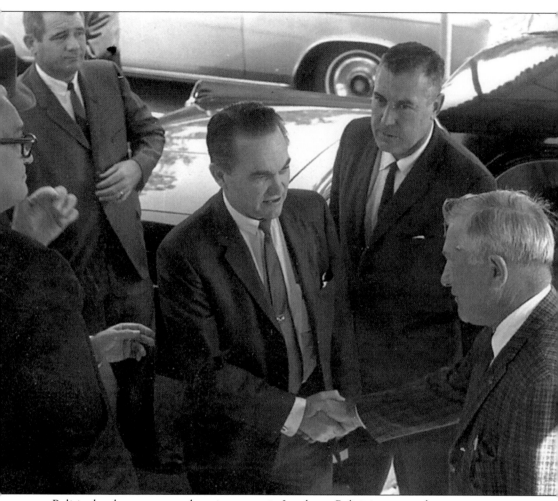

Politics has been an ever-changing scene in Leesburg. Politicians came here to get votes, meet the people, and enjoy great hospitality. In 1968 George Wallace stopped in Leesburg to shake hands with locals. Sterling Harrison, Loudoun County's Commonwealth attorney, is standing to the right of Wallace. (Photograph courtesy Wynne Saffer.)

Clerk of the Circuit Court Richard Kirk administers the oath of office to James Clem as mayor of Leesburg in 1994. During Clem's administration big changes took place with rapid growth and development.

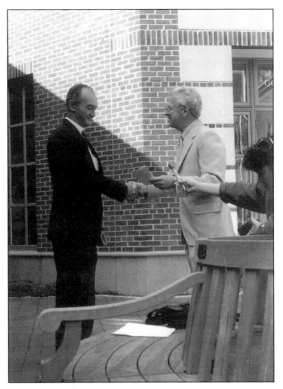

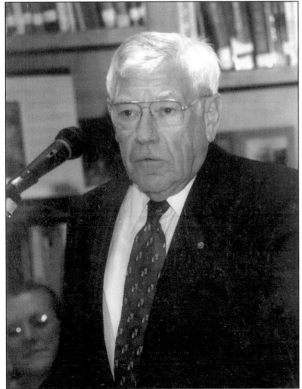

George Atwell has been in the town political scene for a number of years. An educator in the local school system, he was a member of the Leesburg Town Council and was instrumental in getting the town to purchase the Thomas Balch Library from the county.

35

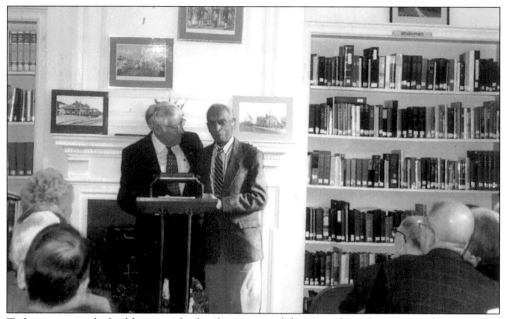

Today many roads, buildings, and schools are named for one of Leesburg's civic leaders, John Tolbert. In this photograph Mr. Tolbert and George Atwell share a moment in the Balch Library before its renovation in 1998. Both Mr. Tolbert and Mr. Atwell campaigned to save the Balch Library, which is not only a landmark but is now an historical and genealogical library.

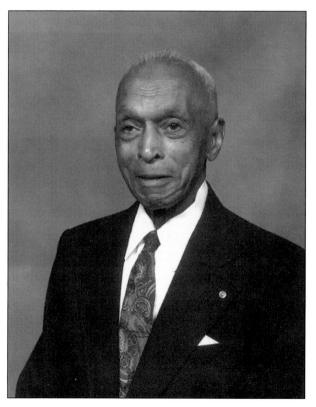

In December 1999 Leesburg lost one of its most active African-American citizens when John W. Tolbert Jr. died at the age of 94. Born in Charles Town, West Virginia, he was a chef and came to Leesburg to work at the Laurel Brigade Inn and later worked for 12 years at Madeira School. He became interested in politics and became Leesburg's first black town council member, where he served for 14 years. He was also a member of several commissions including the Thomas Balch Advisory Commission. He attended St. James Episcopal Church and lived in Leesburg for almost 50 years. One of the best cooks this author has ever known, his ham biscuits and baked chicken were legendary.

Another familiar face in Leesburg is Russell Baker, host of *Masterpiece Theater*. Russell grew up in Loudoun County and was a journalist for the *Baltimore Sun* and *New York Times*, Washington Division. He has written several books and one, *Growing Up*, talks of his youth in Morrisonville, about 12 miles from Leesburg. Russell can be seen in downtown Leesburg, enjoying the company of his many relatives in the area.

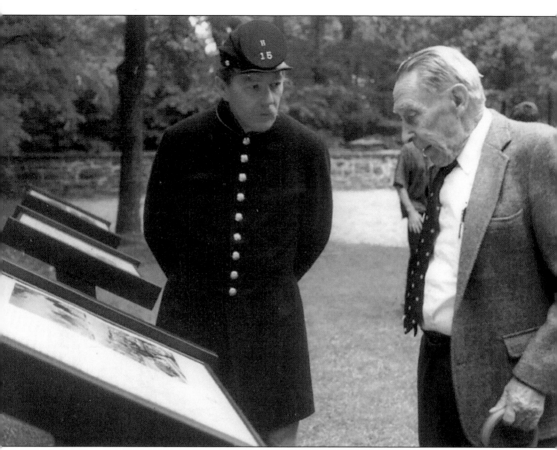

John Divine (1911–1996) was without a doubt one of the premier Civil War historians of his time. Here, he takes a tour of Balls Bluff National Cemetery near Leesburg. Born in Waterford, he lived his later life in Leesburg. He was featured on the television network "The History Channel." His portrait, hanging in a room dedicated to his memory at the Balch Library, overlooks the Civil War collection. His knowledge was unsurpassed and you could tell from the twinkle in his eye when he told his stories that he loved sharing that knowledge with everyone.

This is Mayor B.J. Webb at the podium in the newly renovated and expanded Thomas Balch Library in 2001. Balch Library is said to be one of the most beautifully renovated buildings in Leesburg and it has won several architectural awards.

From left to right, Deputy Town Manager Phil Rodenberg and associate Nicole Ard, along with intern Shannon Bridgeman, enjoy the opening of the renovated Balch Library from the front porch in 2001. The Town of Leesburg owns and operates the Thomas Balch Library, located on Market Street, as a library for history and genealogy.

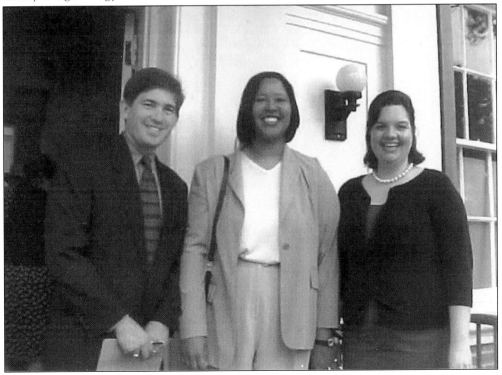

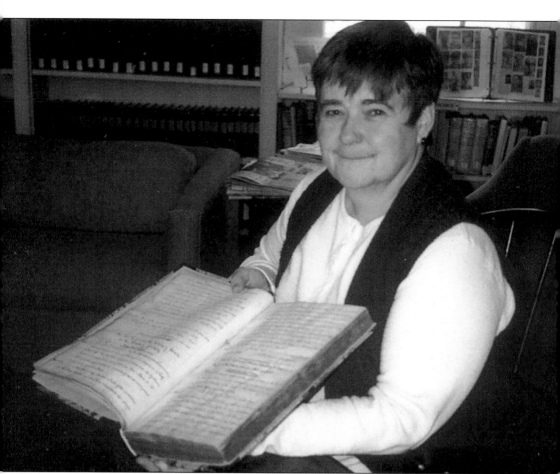

Jane Sullivan is the library manager for the Thomas Balch Library. Jane comes from Massachusetts and stayed with Balch Library when ownership moved from the county to the town. A great asset to the library, she is shown here holding one of the many old books contained in the collection that tell wonderful things about Loudoun and its history. Jane has been with the library system for 17 years and has served as Balch manager for 11 years.

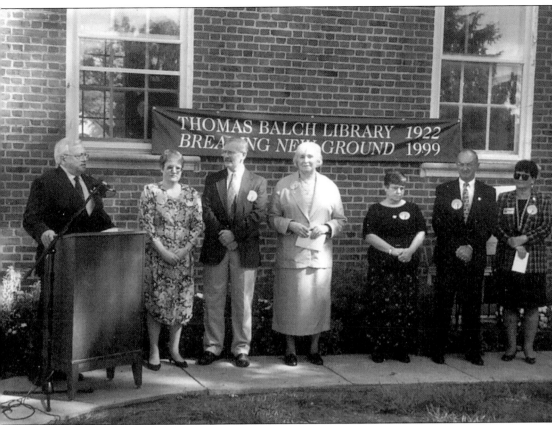

The Thomas Balch Library in Leesburg was built in 1922 and designed by the famous architect Waddy Wood. The building was acquired in 1994 and was renovated as a library for history and genealogy. In 1999 the town broke ground for the building's renovation and expansion. The following are some of the Thomas Balch commissioners at the groundbreaking ceremony: (from left to right) James P. Lucier, Mary Fishback, Jim Hershman, Joan Rokus, Jane Sullivan (library manager), James Clem, and Karen Jones, president of the Friends of Balch Library. Balch Library re-opened in 2001.

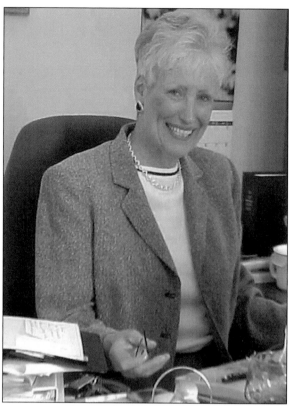

Nancy Fixx has been employed by the Town of Leesburg for 22 years. She is currently the manager trainer for the town and is in charge of the health and safety programs.

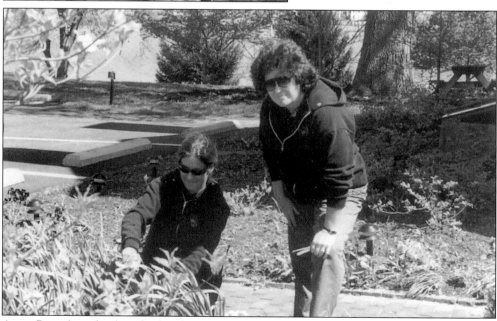

Anne Rose (standing) is the head groundskeeper for the Leesburg Department of Parks and Recreation. Lynn Condon (kneeling) is the groundskeeper and horticulturalist. These ladies, and many others with "green thumbs," help to maintain the beautiful gardens and parks that make Leesburg a wonderful place to live and work.

Robert G. Sharp served as the first town manager of Leesburg from 1961 to 1963. He was a civil engineering graduate of Purdue University. The rapid growth of Leesburg started at this time and since no by-pass existed, all traffic passed through town. A traffic light was installed—only the second in town—at the intersection of King and Loudoun Streets. House numbers were assigned so home delivery of mail could be initiated. Up until this time all residents got their mail at the post office. Robert remains a resident of Loudoun. (Photo courtesy Barbara and Robert Sharp.)

Robert S. Noe Jr. has served as town manager of Leesburg since September 1999. Born in Norfolk, Virginia and raised in North Carolina, he has more than 30 years experience in local government management in Virginia and Florida. Bob is married to Stephanie and has a daughter Jordana. He has the task of managing one of the fastest-growing towns in the country.

Three

POSTCARDS

Postcards are our windows to the past. They allow us to look back in time and view snippets of a bygone era. Most of these postcards were issued between about 1870 and 1960. The collection shown here is largely from the Thomas Balch Library in the Rust Archive Collection. Emory Plaster (1916–2002) donated many of the cards contained in this collection. Some came from the collection of John Fishback. Many of the views show the intersection of U.S. Route 7 and 15, two of the major highways in Virginia. Leesburg has been popular with tourists taking photos for over 100 years. the corners of the crossroads of Route 7 and Route 15 are the subject of thousands of photos that were made into postcards. The quiet, colonial charm of Leesburg has inspired many postcards in the past and today's photographers still produce postcards of this historic, picturesque town.

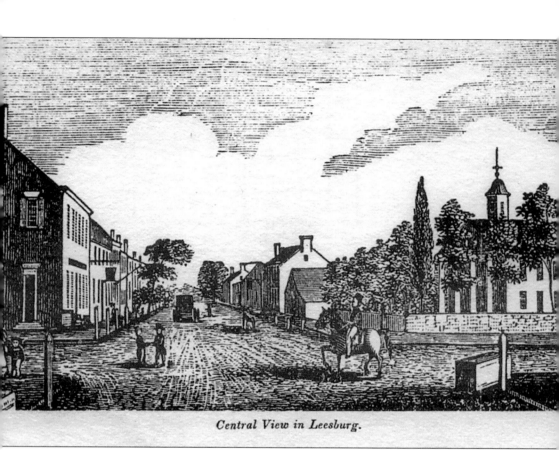

Central View in Leesburg.

This is an artist's engraving of how downtown Leesburg looked in the late 1700s. Note that Route 15 and Route 7 were major traveling routes even then. This engraving shows the first courthouse to sit on the corner of King and Market Streets in Leesburg.

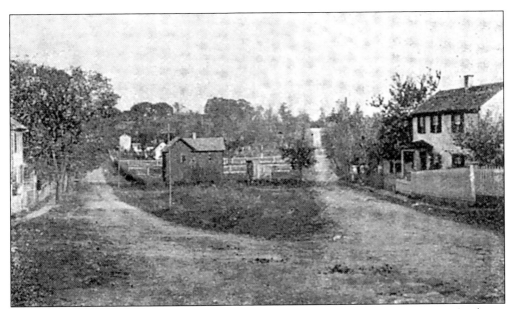

These two classic photo-postcards were taken of East Market and Fayette Streets. You know them better today as Edward's Ferry and Market Streets. The top photograph shows the streets before telephone and electricity was installed in Leesburg. (Emory Plaster Collection, Rust Archive.)

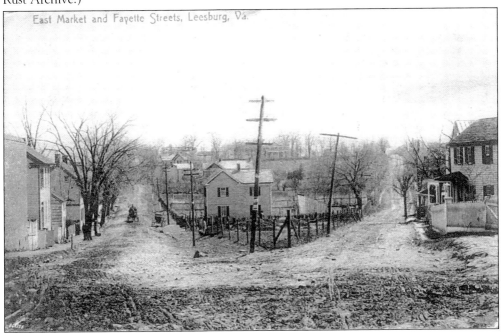

East Market and Fayette Streets, Leesburg, Va.

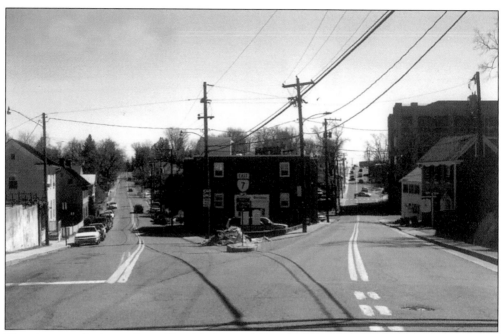

The photograph above shows East Market and Fayette Streets as they appear in 2003, with new buildings and asphalt. This is one of the busier streets in Leesburg today. (Photograph by Fran Poston.)

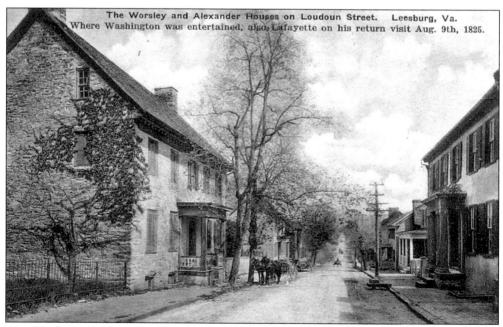

The Worsley and Alexander House on Loudoun Street has entertained such guests as George Washington and Lafayette in 1825. Later, orator Henry Clay is said to have given a speech on the front porch to the citizens of Leesburg. This building is now a business.

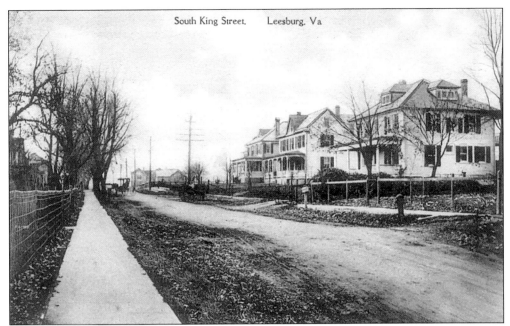

South King Street. Leesburg, Va

This popular postcard depicts South King Street (Route 15 South) before the automobile became popular. The homes remain today.

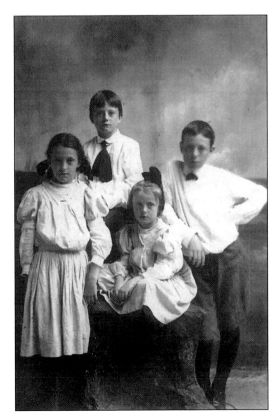

Family group portraits have long been popular with photographers. In this family photograph, which was sent out much like a greeting card, you have four siblings, Connie, Jack, Luck, and Ashby Reardon. The postcard was sent to Leesburg.

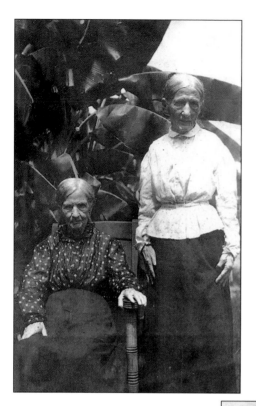

This postcard was sent from Leesburg. It depicts Aunt Ellie and Mattie Archer. These ladies sent this postcard to their families who had moved away to other states.

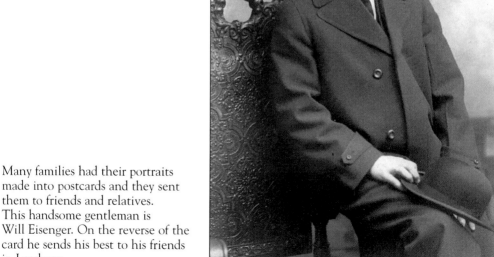

Many families had their portraits made into postcards and they sent them to friends and relatives. This handsome gentleman is Will Eisenger. On the reverse of the card he sends his best to his friends in Leesburg.

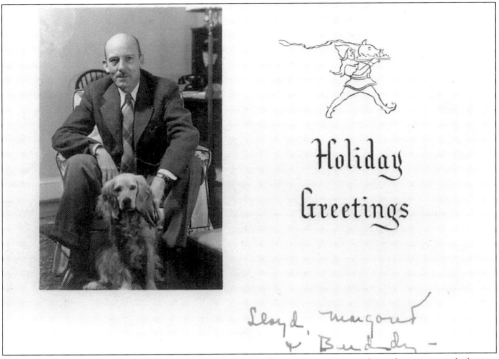

Holiday greetings in postcard form were popular for many years and as this postcard shows, people were not the only subjects. The card is from Lloyd, Margaret, and Buddy. Margaret was not in the photograph, but after all a dog is man's best friend!

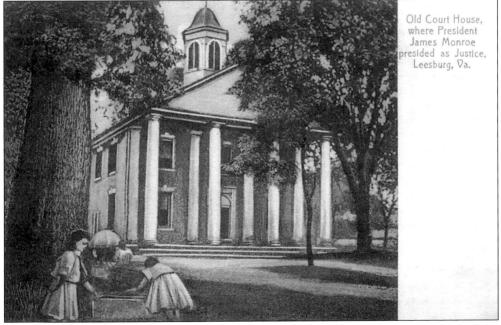

Old Court House, where President James Monroe presided as Justice, Leesburg, Va.

There have been three courthouses on the same site in Leesburg. This is a postcard of the second courthouse. The current courthouse was built in the 1890s. James Monroe's portrait now hangs there with the other portraits of the Justices in Loudoun County.

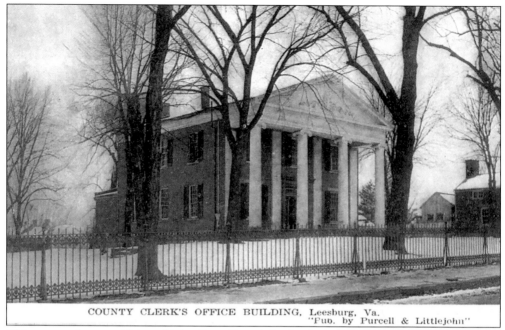

COUNTY CLERK'S OFFICE BUILDING, Leesburg, Va.
"Pub. by Purcell & Littlejohn"

This postcard was widely sold by Purcell and Littlejohn's Drug Store in Leesburg. The photograph was taken c. 1900 and shows the clerk's office that faces Route 7 in downtown Leesburg. The picket fence has been replaced by a wrought iron fence.

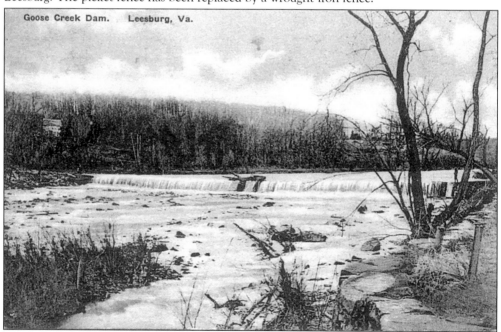

Goose Creek Dam. Leesburg, Va.

Part of Goose Creek has been the dividing line between Fairfax and Loudoun County since about 1790. It originally divided the parishes of Cameron and Shelburne and cut the county almost in half. It has been a major waterway for travel, recreation, and the milling industry for over 200 years. This postcard shows the Goose Creek dam just outside of Leesburg near the turn of the century.

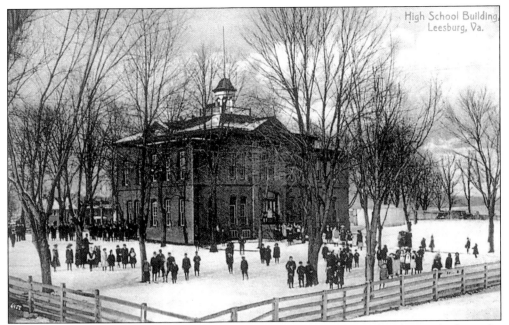

This postcard shows the old Leesburg High School. The school burned and was rebuilt on the same site. The image here was taken prior to 1915.

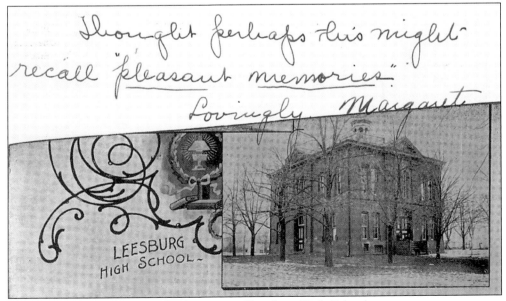

Another postcard is sent as a fond memory of Leesburg High School.

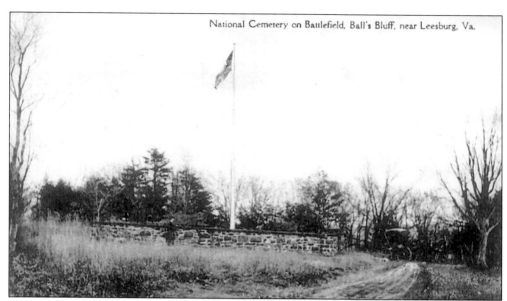

National Cemetery on Battlefield, Ball's Bluff, near Leesburg, Va.

Ball's Bluff is the smallest national battlefield cemetery in the United States. It is located just off of Route 15 north of Leesburg. This early 1900s postcard shows the cemetery with the flag proudly waving over graves of some of the soldiers buried at Ball's Bluff. There are 54 federal troops buried at the cemetery with other monuments outside the walled area. There are guided tours of Ball's Bluff given on weekends in the summer by the Northern Virginia Regional Park Authority. Jim Morgan and Wynne Saffer and others give interpretive talks on the battle itself.

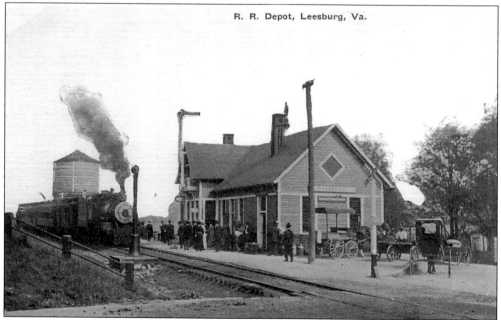

R. R. Depot, Leesburg, Va.

The railroad depot in Leesburg was busy with passengers and freight until 1968. The Washington and Old Dominion, or as we locals called it, "the wobbly old and dilapidated," was the main train through Leesburg. Its tracks were pulled up an it is now part of an extensive park, the W&OD bike trail. It extends from Roslyn, Virginia to Bluemont. Hikers, bikers, and rollerbladers now enjoy this very scenic trail.

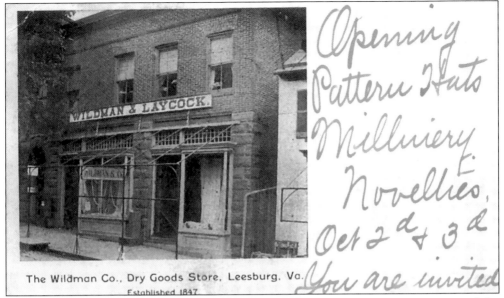

The Wildman Co., Dry Goods Store, Leesburg, Va.
Established 1847

Opening Pattern Hats Millinery Novelties, Oct 2d & 3d You are invited

This early advertising card from the 1890s was sent out inviting one to an opening of the millinery and novelty section in the store of Wildman and Laycock in Leesburg. This store was established about 1847. Postcard advertising is very popular even today.

The Old Stone Methodist Church on Cornwall Street in Leesburg is seen in ill-repair, just before it was torn down. This site is the oldest Methodist-owned property in the United States. It has a cemetery that is maintained by the Old Stone Church Foundation. The Methodists built a new church just two blocks away.

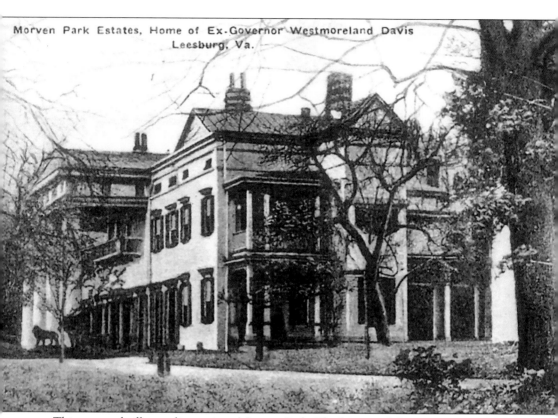

Morven Park Estates, Home of Ex-Governor Westmoreland Davis
Leesburg, Va.

This postcard offers a glimpse into Morven Park. The history of the mansion is as interesting as the people who lived there. The house itself dates from about 1808 and was built by the Swann family of Maryland. Gov. Thomas Swann inherited the property from his father, Judge Thomas Swann. The governor used Morven Park as a summer residence and his retreat house from offices in Baltimore. Morven is said to have been built by the Baltimore firm of Lind and Murdock. Attorney General William Wirt was a student of law under Judge Thomas Swann at the mansion. Gov. Westmoreland Davis (1859–1942) acquired the property in the early 1900s. Davis turned the estate into a showplace for his favorite pastimes such as riding, hunting, and agricultural and political pursuits. Davis was a farmer, and top breeder of turkeys, bulls, and horses. He held an interest in the *Loudoun Times* Publishing Company in Leesburg for a number of years and also bought the *Southern Planter*. Davis and his wife, Marguerite Inman Davis, are buried on the property. In 2003, Morven Park is undergoing major restoration. It is open to the public, has extensive gardens, and houses the Winmill Carriage Collection. Morven Park is one of the best historic sites to see in Leesburg.

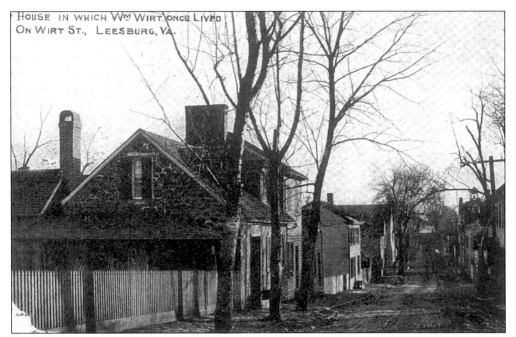

A landmark house for Leesburg is on Wirt Street. It was probably built c. 1790 and is part log. Attorney General William Wirt owned the house at one time. Mrs. John Carr bought it around the time of World War I and paid about $4,000. There have been several additions over the past 100 years.

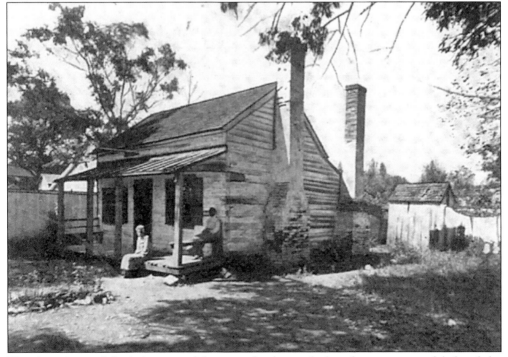

This is a nice card depicting one of the many log homes before they were remodeled and the logs were covered over or torn out.

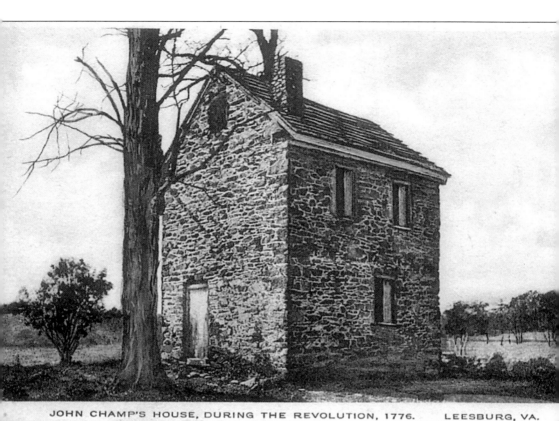

JOHN CHAMP'S HOUSE, DURING THE REVOLUTION, 1776. LEESBURG, VA.

This house was said to be the home of John Champe, of Revolutionary War fame. The house was destroyed to make way for a large shopping center on the Route 15 bypass. John Champe's memory lives on in Loudoun as there is a Sgt. Maj. John Champe Chapter of the Sons of the American Revolution.

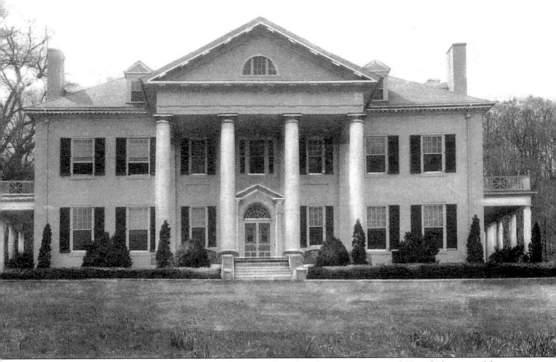

This is "Selma," the home of Col. E.B. White. Colonel White was a noted Confederate soldier and later a banker in Leesburg. This once-large estate is now part of a subdivision. The main house is maintained with minimal land. Selma is on Route 15, very close to Leesburg.

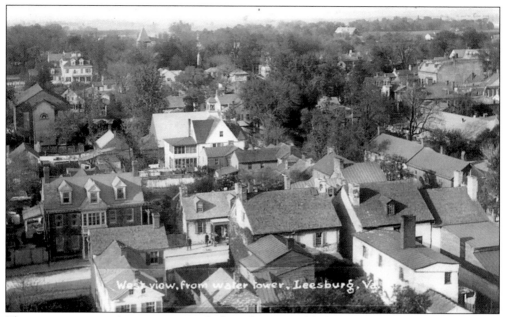

This is a controversial picture-postcard of Leesburg. It is labeled as "West view from the water tower." However, from the location of the old water tower, the view would appear to be from the north. No matter, this is a great overview shot of Leesburg in the mid-1950s. It has changed drastically in the last 50 years.

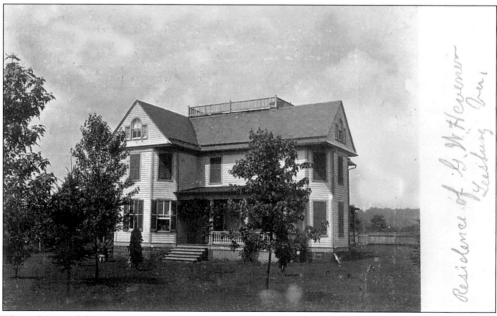

The subject of this postcard is of the home of G.W. Havenner of Leesburg. Many of us would enjoy finding postcards of our homes years ago.

Four

THE FRANK RAFLO COLLECTION

Frank Raflo has been a household name in Leesburg since about 1940. He was born in Leesburg on December 9, 1919, the son of Joseph and Fanny Raflo. He graduated from the old Leesburg High School and is a 1940 graduate of William and Mary College. He married Frances Atwell and they had four children, Josephine, Alan, Phil, and Paul. Frank has served Leesburg as a member of the town council and as mayor of Leesburg from 1961 to 1963. He served on the Loudoun County Board of Supervisors from 1972 to 1986. He has served on many civic boards such as the Mental Health and Retardation Board, and the Northern Virginia Park Authority, just to name a few. His business career spans over 60 years. He was the editor of the local newspaper, Loudoun News, *from 1942 to 1949. He and his family ran "Raflo's," a clothing store in downtown Leesburg from 1949 to 1976. In 1961 Frank was named "Man of the Year" by the Loudoun Chamber of Commerce. He served as a founding member of the Kiwanis Club in Leesburg. He was president of the Northern Virginia TB and Respiratory Disease Association and has served as president of "Keep Loudoun Beautiful." The author of two local history books,* Within the Iron Gates *and* Hauntings and Happenings, *he currently writes a column for the local newspaper* Leesburg Today *entitled "Just Being Frank." For over 70 years Frank Raflo has educated us, enlightened us, and entertained us with his humor and wit on almost any subject. You can count on Frank to have an opinion on everything! You can enjoy Frank and his unique opinions at the Leesburg Restaurant where he usually sits at the "power" table for lunch.*

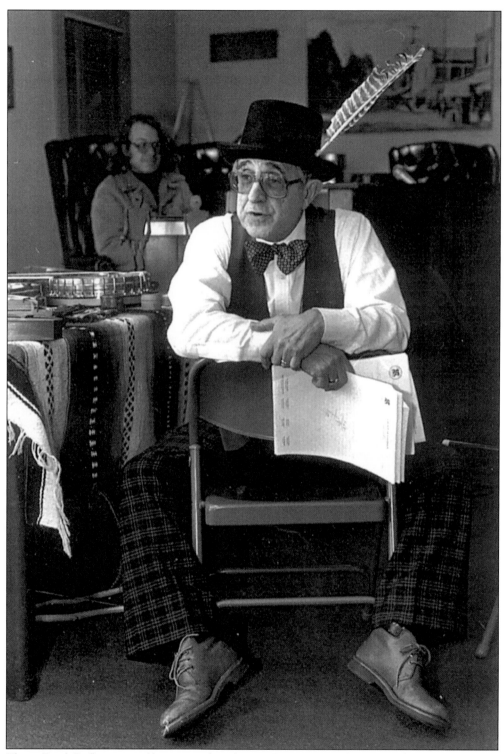

This is Frank Raflo in one of his more relaxed poses. Bow ties are a favorite with Frank and as you can see, he will do almost anything for a laugh. The feather adds a nice touch to the outfit.

Frances Atwell Raflo has helped to raise four beautiful children and assisted Frank in running the family business and his political career. Frances has held many civic posts over the years. She has been on the League of Women Voters and was director of the Chamber of Commerce and is a member of the Loudoun Restoration and Preservation Society. She has also worked at the Loudoun Land Institute and Raflo's Department Store. Currently she is active in tourism and economics in Loudoun County.

The machine guns were a familiar sight to many people in Leesburg. These guns were displayed on the courthouse lawn and were great fun to young and old alike. They have since been removed and are now in storage.

These are two great snapshots of
Josephine Raflo, Frank's daughter. One of
them was taken when she was young and
the other at about age 20.

Animals were a favorite of the Raflo family. Here Ranger does tricks for (from left to right) Frank, Phil, Frances, Paul, and Alan.

Phil and Alan share some playful times with their dog.

Frank and Frances had many friends and went to many fundraisers. Here (from left to right) are Virginia and Ben Lawrence and Terri and Earl Bell, owners of Leesburg Chrysler Plymouth car dealership. Notice the Jimmy Carter lapel button.

Tonto was an all-time favorite cat for Frank. Tonto always read the news before him.

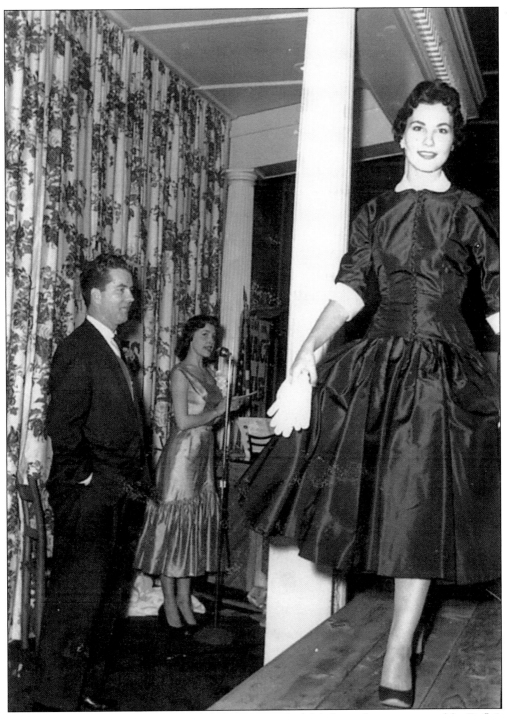

This is a great photograph of one of the many wonderful fashion shows sponsored by Raflo's Fashion Store. Raflo's was a fashion spot for the women in town for over 50 years.

Former mayor Frank Raflo is pictured in 1963 at the groundbreaking of the new Godfrey Field Airport in Leesburg. Stanley Caulkins, a longtime jeweler in Leesburg, is still active in the Airport Commission in 2002. George Hammerly and Maurice Lowenbach Jr. were all instrumental in getting the Godfrey Field Airport project completed.

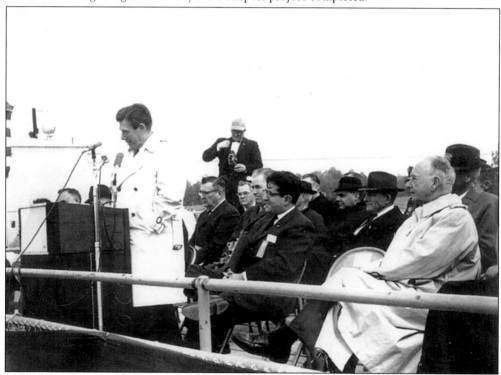

When the Federal Aviation Building was dedicated in Leesburg, there were many notables who attended the ceremony. Arthur Godfrey was the keynote speaker for the event. Emory Kirkpatrick, Mayor Frank Raflo, and Sen. Harry Byrd all listened intently. Frank had a political audience from Loudoun to Richmond.

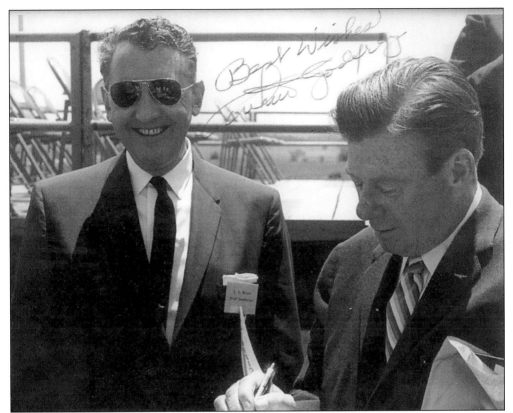

Arthur Godfrey was a big radio star who owned Beacon Hill just west of Leesburg and he was on hand for most major events in Loudoun County. Here, Godfrey is signing autographs and talking to Chief FFA controller C.C. Watson. Frank was on hand to get a photograph.

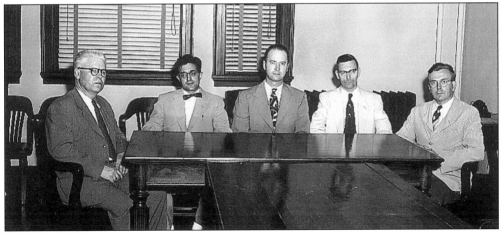

This shows a meeting of some of the Leesburg town council in the 1960s. From left to right are George Ward, Frank Raflo, unidentified, Emerson James, and Reg Gheen.

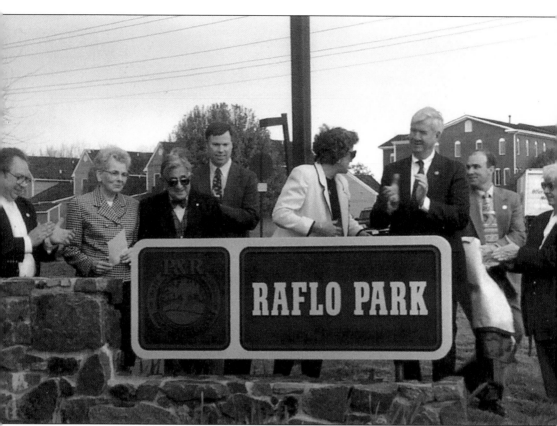

Raflo has had many honors in his amazing life. Here, Frank is honored by the Town of Leesburg as they name a park on Harrison Street in his honor. This dedication photograph shows (from left to right) Joe Trocino, Frances Raflo, Frank Raflo, Frank Buttery, Mayor B.J. Webb, Charles Waddell, unidentified, and Jewel Emswiller exchanging remarks at the newly dedicated Raflo Park.

Five

THE DAVID FRYE COLLECTION

David Frye was born in the Shewbridge family home in Brunswick, Maryland. He was brought back to their Leesburg home by his parents when he was less than one week old and has lived in Leesburg ever since. David began taking photographs at an early age as a hobby. As a result, he has taken photographs that have been published in the local newspaper, the Loudoun Times Mirror. In the 1960s David worked for Howard Allen Studios in Middleburg. He married Donna Bell in 1961 and they have two children, Kim and David. David was with the Leesburg Volunteer Fire Company for 10 years and served as treasurer for 2 years. David worked for the Town of Leesburg as superintendent of the streets, Building and Grounds Division, and retired in 2001 after 26 years. As you can see from this collection, he photographed a lot of Leesburg between the 1950s and the 1970s. His works allow us to glimpse how life was in this town. It is through photographs like David Frye's that we are able to view history from a unique and casual perspective.

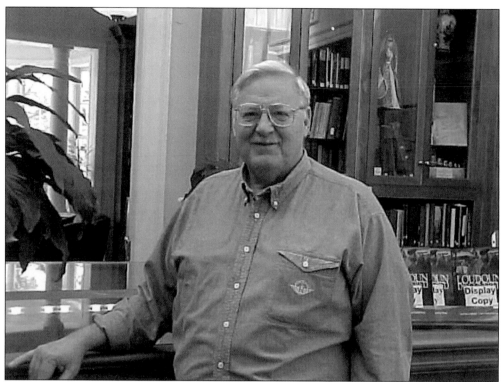

This photograph of David Frye was taken in March 2003 at the Balch Library in Leesburg. David has been a Balch patron for many years.

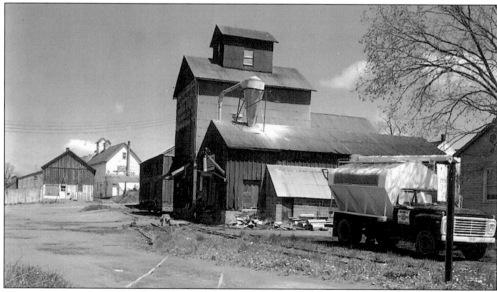

The retail complex today known as "Market Station" was at one time called the "Wharf" by the locals, maybe because it was built near the town branch. This photograph of the "Wharf" area shows Max Davis' junkyard on the left and the taller building is Leesburg Grain and Feed, owned by Herbert Bryant. The C.C. Saffer Mill, which dates from some time in the 1870s, was owned by the Saffer family until the 1940s and stands in the foreground.

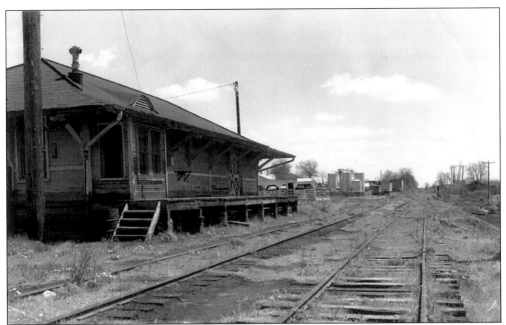

The old freight station, with the Leesburg stockyards in the background, have all but faded from memory. The station was demolished, the stockyards burned, and the railroad right-of-way is now the W&OD bike trail.

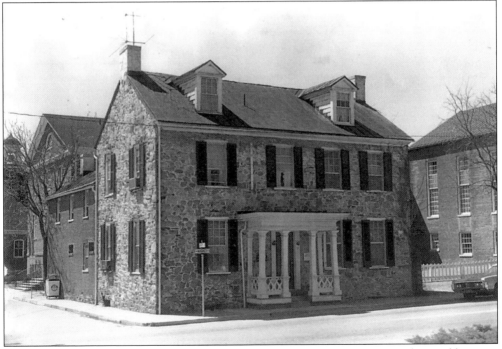

The Daniel Triplett house, a "rubblestone" house, was built about 1802 with an addition to the rear. This handsome structure is located on the corner of Market and Wirt Streets, one block from the downtown Leesburg main intersection. This building has housed families and businesses for 200 years but still maintains its antique charm.

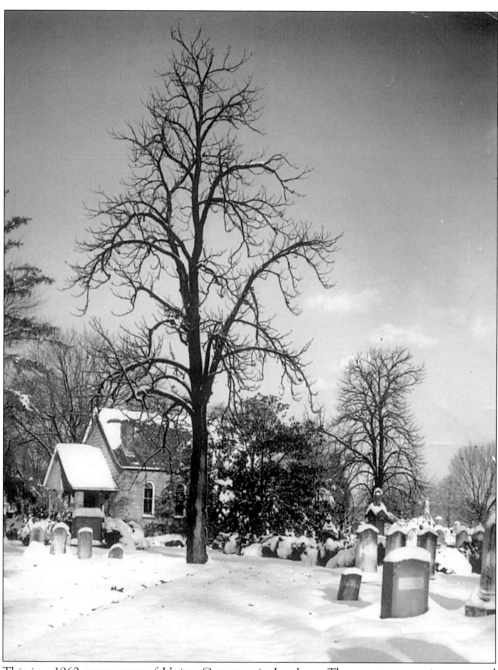

This is a 1960 snow scene of Union Cemetery in Leesburg. The cemetery was incorporated in 1852 and is the largest in town. The original board members were James B. Beverly, Thomas Knox, Armistead Vandevanter, Daniel G. Smith, Charles Tebbs, James Harris, Asa Jackson, William Gray, John Hoffman, Addison Clarke, James Garrison, George R. Head, James Steadman, L.W.S. Hough, and Edward Hammat. According to research, Mrs. Elizabeth Garrison was the first person buried in the cemetery in February 1853. The cemetery chapel, built in 1908 by Henry Jefferson Houpt, one of the first people to use concrete in Loudoun bridges, is no longer used today.

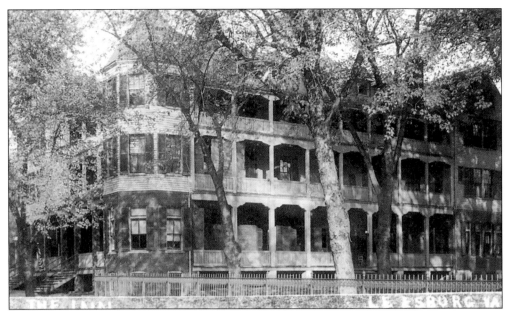

The Leesburg Hotel was built in 1894 by local builders, the Norris Brothers. It operated under a variety of names including the Ketoctin Inn and the Leesburg Inn. Travelers from Washington, D.C. and many other localities came to stay at the Leesburg Inn. A 1946 newspaper ad shows that meals were served seven days a week. A club breakfast was 30 cents to 75 cents, weekday dinners were 85 cents for adults and 50 cents for children, and Sunday dinners were $1.40 for adults and 75 cents for children. In the 1960s the building was used for a variety of businesses. Standing adjacent to the courthouse square, it was purchased by the county and demolished in 1974 to make room for a new county clerk's office. (Photograph courtesy Balch Archives.)

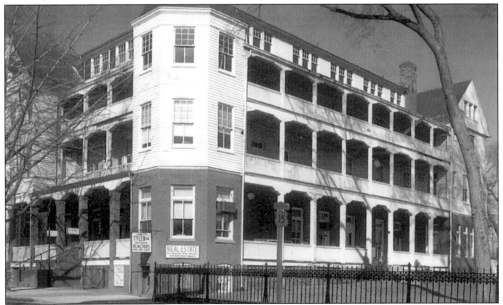

This is a wonderful photograph of the old hotel in the 1960s. One wonders why such a lovely old building was demolished. (Photograph courtesy David Frye.)

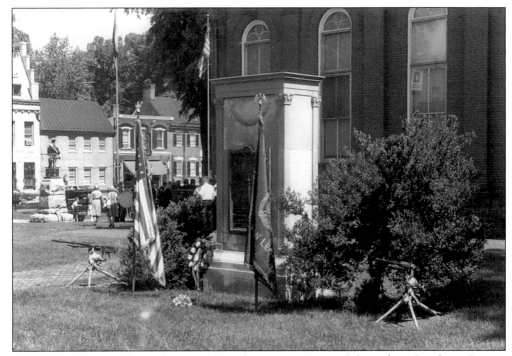

This monument stands on the courthouse lawn in memory of those from Loudoun County who died during World War II. This view shows Memorial Day tributes placed in honor of the dead. The machine guns have been removed and are currently in storage. This is one of several monuments honoring Loudoun's military dead located in the courthouse square.

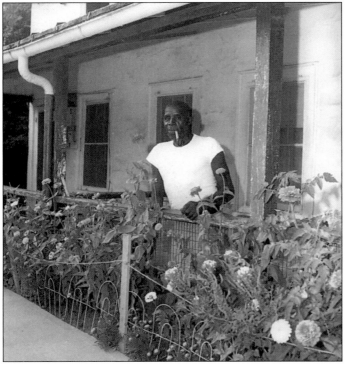

This house stands in the area once known as "Murderer's Bay." It is believed the name came from the area being located near the gallows for the town. Another tale is that the area was used by rogues to keep horses for fast getaways! It is near Mt. Zion Methodist Church in what was predominantly an African-American neighborhood. The gentleman standing on the porch is Milton Henry Ball who lived in the house for a number of years. From 1978 to 1989 the author lived in the house which stands next to one of Leesburg's many parks.

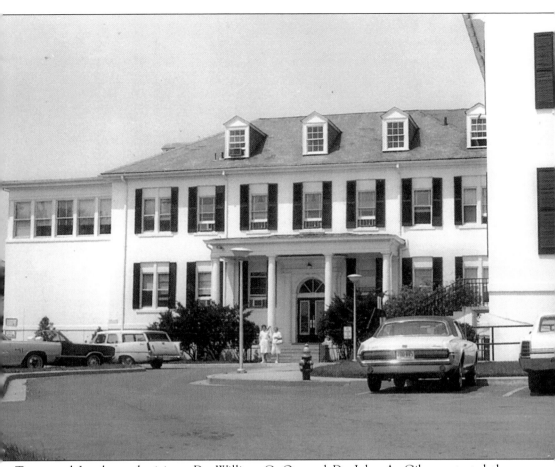

Two noted Loudoun physicians, Dr. William C. Orr and Dr. John A. Gibson, started the Loudoun Hospital in 1912 in downtown Leesburg in a $30/month rented space. P. Howell Lightfoot was appointed manager and Miss Catherine Oxley was superintendent of nurses. It had six rooms, one bath, and was heated with wood stoves. The next hospital building (shown above) was completed in 1918 with quarters for the off-duty nurses on the third floor. The Nurses Home (left in photograph) was built about 1926. The Training School for Nurses at Loudoun Hospital operated from 1913 to 1931. In 1949 a wing was added to the hospital and in 1974 a 216-bed addition was completed. Today Loudoun Health Care Center is located at Lansdowne outside the town limits.

The property this barn was built on has quite a history in Leesburg. The barn was used in the early 1900s by Mr. Grimes, a rural mail carrier, for his horse and buggy. This property went from being rural to being the center of the Loudoun County government in a span of less than 75 years. (Photograph courtesy Balch archives.)

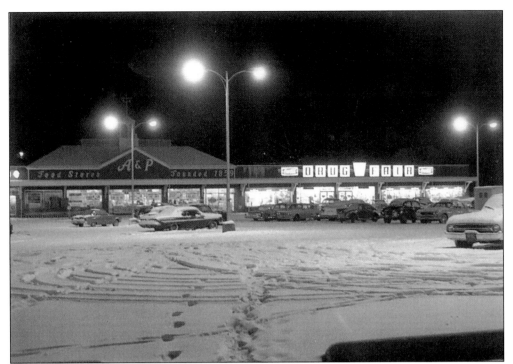

The Grimes property later became the site of the Firestone Company, A&P Food Store, and Drug Fair as shown in this 1960s photograph. This building was later utilized as antique shops before being demolished. (Photograph courtesy David Frye.)

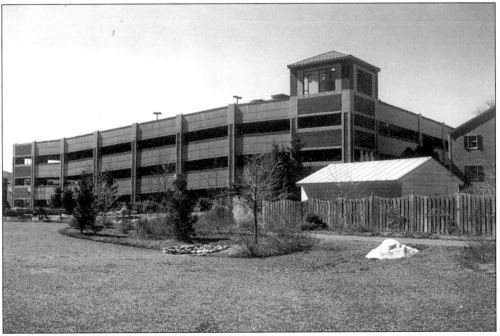

The Firestone, A&P, and Drug Fair were demolished in the 1990s to build a new County Government Center and parking garage. (Photograph by Fran Poston.)

This is a 1960s view of the west side of King Street looking north in the direction of Frederick, Maryland. The stores have changed owners and the sidewalks are now brick, but the view hasn't changed much. The Silco store and Nichols Hardware are gone but Leesburg Restaurant is still "the" place to meet and eat in the downtown area. (Photograph courtesy David Frye.)

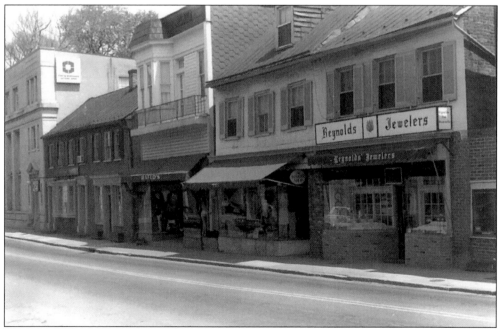

This is the east side of King Street looking north in the 1960s. The stores and bank have closed and the buildings are now a newspaper office, antique shops, and offices. Frank Raflo was born above Raflo's Store in the room that opens onto the balcony.

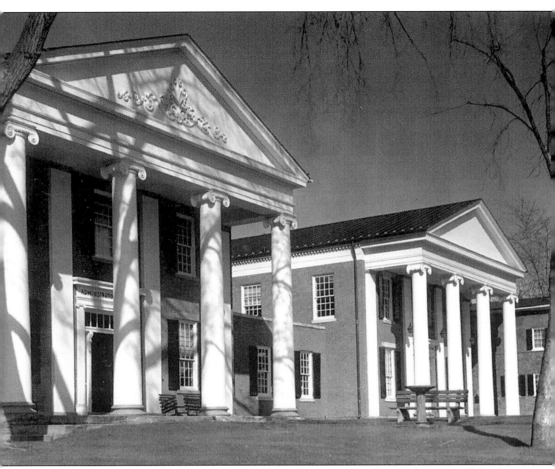

This is a photograph taken in the 1960s of the old Academy Building (in the foreground), built in the 1840s, and the Circuit Court Clerks Office building, in the mid-20th century. Though constructed in the classical Greek Revival style, the carved anthemion and scroll decoration in the pediment of the Academy Building was removed in the 1980s. It is known as the Academy Building because it once housed a boys' school. The building was purchased by the county in the 1870s and was used to house the clerks office and other county offices. In the early 1950s the county bought and demolished the W.W. Chamblin house just east of the Academy Building and built a duplicate of the Academy Building. The clerks office and county offices then utilized space in both buildings. (Photograph courtesy David Frye.)

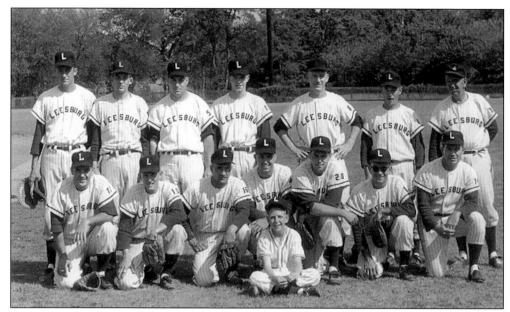

Sports have long been a favorite way to pass the time in Loudoun. This Leesburg baseball team was tops in leagues standing in the 1960s. Shown here are (front) Bradley Kidwell; (first row, from left to right) Buddy Frye, Hubert Goode, Carleton Kirk, Tommy Lloyd, Jimmy Kidwell, Curle Tiffany, and Preston Newton; second row unidentified, Speedy Fields, Donald Beach, unidentified, John Vance, Tommy Cooke, and Mr. Hutchison.

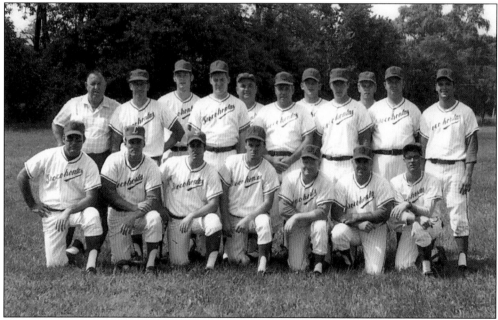

Many local businesses sponsored teams. This team was sponsored by Pocohontas Pontiac. The photograph dates from the 1960s. Pictured are (kneeling) James Degan, unidentified, Terry Atwell, Sid Mercer, Tommy Lloyd, unidentified, and Rickie Donaldson. Standing are Arnold Pfifer, Bill Wrenn, David Daniel, unidentified, Foxy Furr, Jimmy Kidwell, four unidentified, and Jerry Peterson.

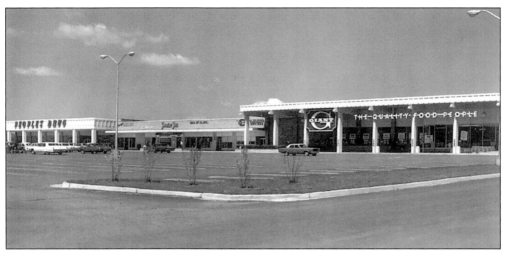

One of the major changes in the 1960s and 1970s was the development of Route 7 east of town. This shopping center with Giant Food, Peoples Drug Store, and other shops was the beginning of a new way to shop for Leesburg and Loudoun residents. The Giant has moved to a bigger store a short distance from the old store and Peebles Department Store now occupies the Giant building.

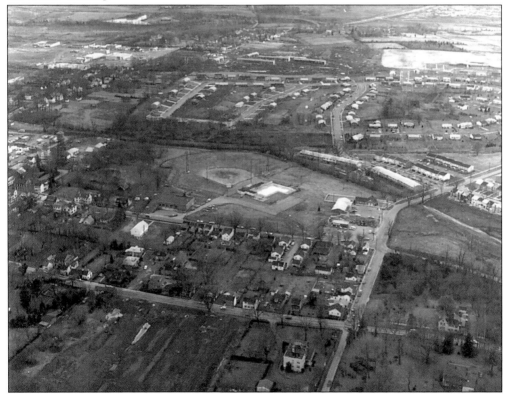

This aerial photograph was taken about 1964. In the center is the Fireman's Field with the ball diamond and swimming pool. The road to the right is Dry Mill Road that runs past Loudoun County High School and the road at the bottom is Route 7. Fireman's Field is now a housing development.

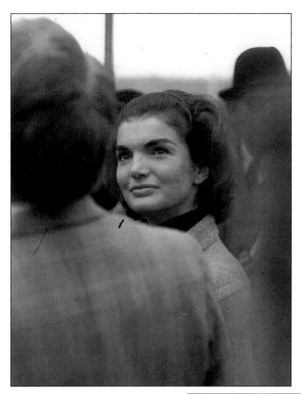

President John F. Kennedy and his wife Jackie visited Loudoun County often. These photographs by David Frye show Jackie Kennedy at the Middleburg Races and the President and his wife at Middleburg Community Center. Jackie was very active in the local hunt scene and rode with the hunt at Rockland and Morven Park. The Kennedys were just two of the rich and famous from Washington that used Loudoun for recreation and relaxation. They built a home here called Wexford. (Photo by David Frye.)

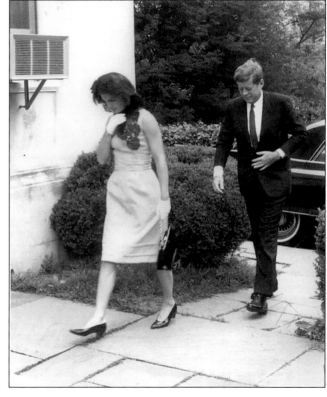

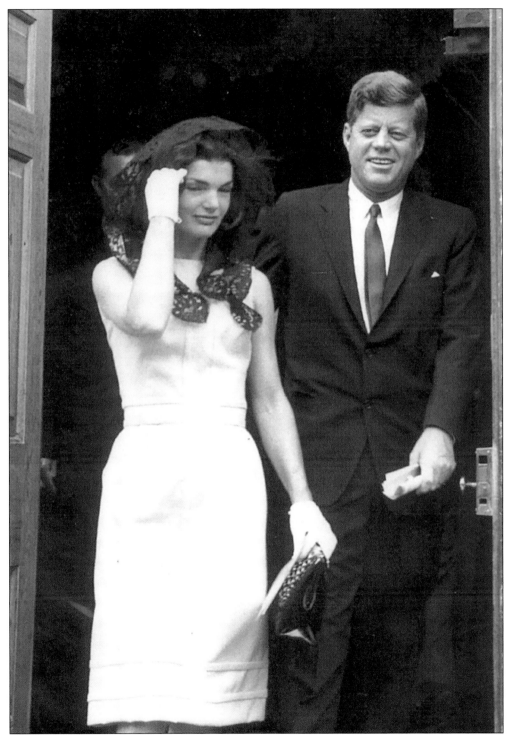

In this photograph John F. and Jacqueline Kennedy leave Middleburg Community Center after Mass. David Frye captured many candid shots of the Kennedys when they visited Loudoun County. (Photo by David Frye.)

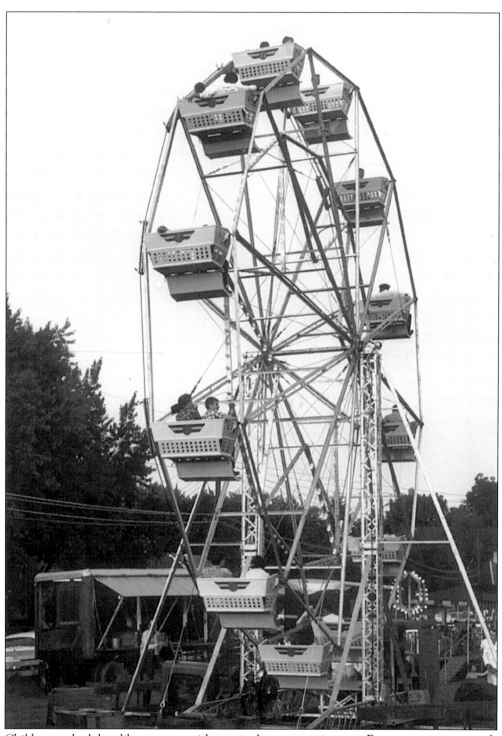

Children and adults alike grew up with carnivals as entertainment. For many years carnivals were held at the Fireman's Field in Leesburg. One of the main attractions was the Ferris wheel. What a treat it was to eat cotton candy and ride the big wheel!

David Frye and his wife Donna have long been associated with the Leesburg Volunteer Fire Department. Shown in the picture taken by David in the late 1960s are (front row, from left to right) Dan Hyatt, Tommy Watkins, Jerry Smith, Bill Fleet, Ron McCue, Nelson Downs, Greg Stocks, Bradley Kidwell, Bob Zoldos, and Harry Leigh. In the top row are Frank Howard and Terry Frye.

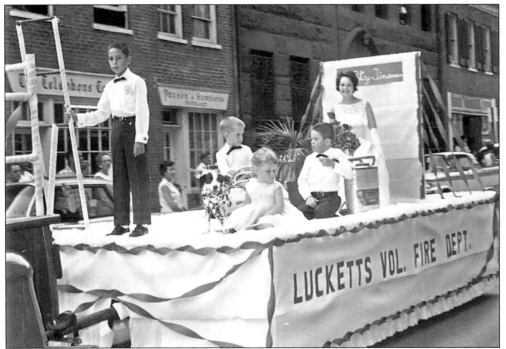

This 1960s view of a parade in downtown Leesburg shows the Lucketts Volunteer Fire Department float with Patsy Tinsman as honorary fire chief. In the background are the Loudoun Telephone Company and Paxson and Hawthorne Insurance buildings.

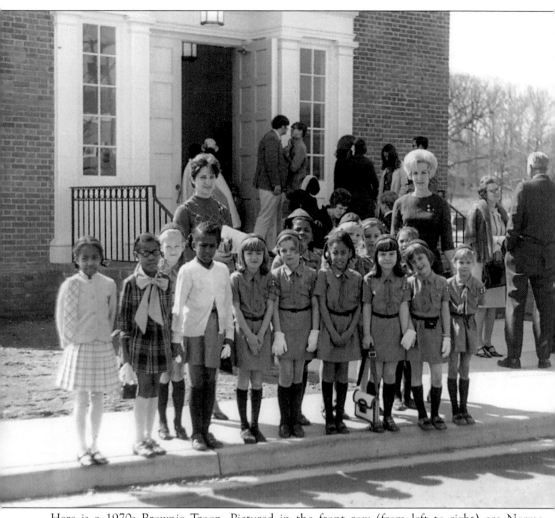

Here is a 1970s Brownie Troop. Pictured in the front row (from left to right) are Norma Dade, Gracie Roberts, Jackie Day, Penny Wine, Kim Frye, Gina Chinn, Cindy Dick, and two unidentified people. In the back row are Linda Ellis, Linda Wright, Kathy Spinks, Sherry Wine, and unidentified. The troop leaders were Mrs. Spinks (right) and Mrs. Balmer (left).

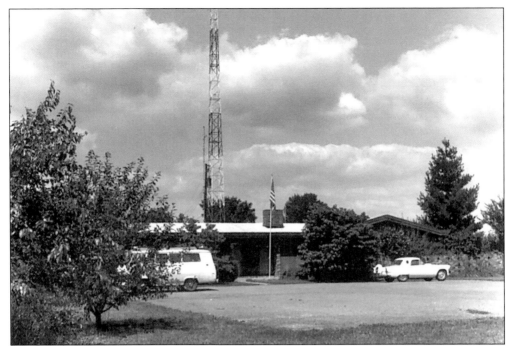

WAGE, the local radio station for Leesburg and Loudoun County, was begun in the 1940s by John Gill and others. This 1960s photograph shows the radio station when it was small, but it looks much the same today. Notice the 1958 Thunderbird parked in front. Paul Draisy and Tim John are two of the current DJ's who report the news for Loudoun and vicinity. Known as the "voice of Loudoun" for over 20 years, Paul is leaving WAGE in 2003. (Author's photograph.)

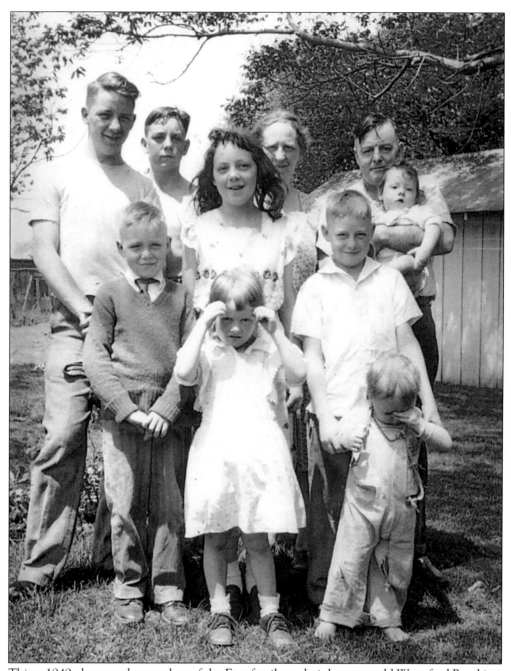

This c. 1949 photograph was taken of the Frye family at their home on old Waterford Road just outside Leesburg. Pictured in the front row (from left to right) are Kermit, Carol, Kelly (with head down), and David; in the middle row is Sharon; and in the back row are Dickie, Buddy, Dorothy (mother), and Norman (father) holding Terry. The Frye family can trace their history in Loudoun County back for over 200 years.

Six

FROM THE
RUST ARCHIVES

The Thomas Balch Library is the home of the Rust Archive that contains over 20,000 photographs and negatives. The best collection is the Winslow Williams collection with pictures that date from the 1930s to the 1970s. Others have added to the Rust Archive over the years, donating photographs of people, places, and events in Loudoun County. Some of the people who have donated the photographs that make the Rust Archive one of the premier photographic collections in Virginia are Russell Gregg, Hugh Grubb, Jane Bogle, Pete Gray, Ann Thomas, Louisa Hutchison, Fran Poston, and the author. The part of the collection shown here depicts old Leesburg from the early 1900s to the 1960s. The Rust Archives was made possible by generous donations by members of the highly esteemed Rust family of Virginia. Their generosity will enable the Balch Library to house and protect many items of historical and genealogical interest to its patrons now and in the future.

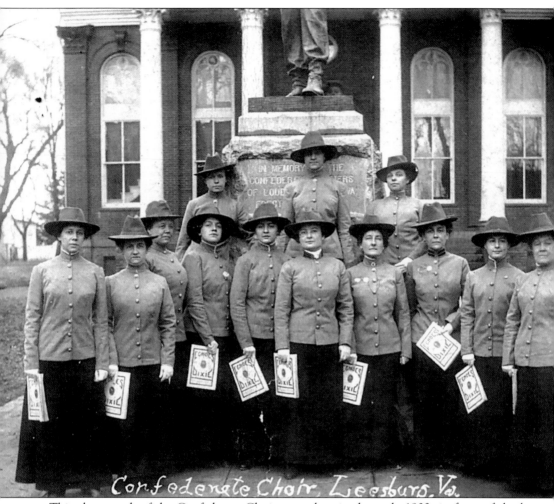

Confederate Choir, Leesburg, Va.

This photograph of the Confederate Choir was taken in the early 1900s in front of the base of the Civil War monument on the courthouse lawn. The ladies are not identified in the photograph, but the following names appear on a list of the members: Nannie Cook, Onice Gallaher, Gertrude Hoffman, Rebecca Jackson, Helen Jacobs, Florence Nixon, Eugenia Thomas, Anna Beuchler, Mrs. Chester Cooksey, Mrs Walter Chamblin, Mollie Thomas Laycock, and Mrs. Charles R. Norris.

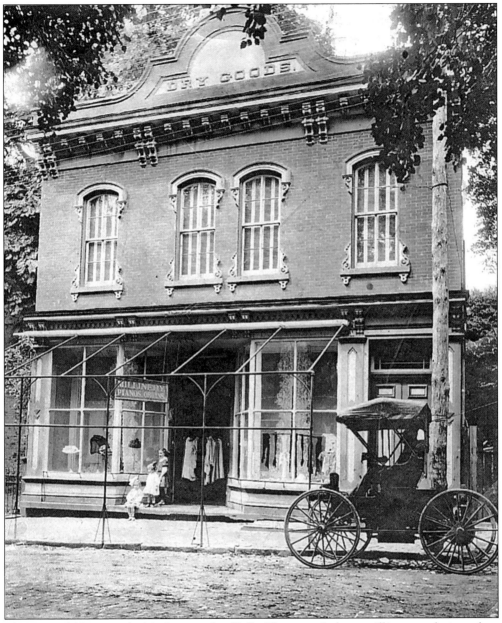

This is an old but wonderful photograph of Lilly Thompson's dress, millinery, and piano shop in downtown Leesburg about 1900. The building looks much the same today.

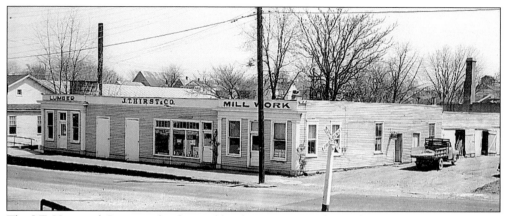

The J.T. Hirst and Company lumber and hardware store was located on south King Street near the town branch for many years. Several floods later, the company moved to Catoctin Circle where they still sell quality lumber and hardware after over 50 years in business.

This *c.* 1938 view shows the McDonald and Jenkins Service Center and Garage. The building faces Market Street and has housed many businesses over the years.

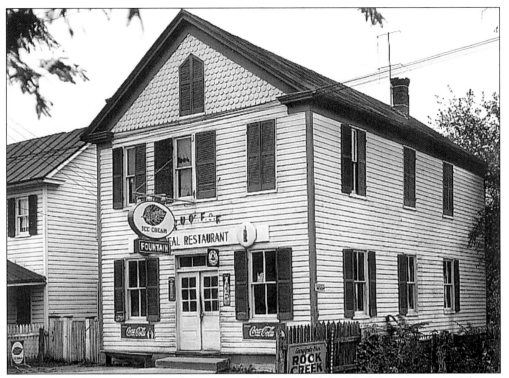

These 1940s photographs show the interior and exterior of the Ideal Restaurant, an African-American business located on Royal Street, one block from downtown Leesburg. The building still stands.

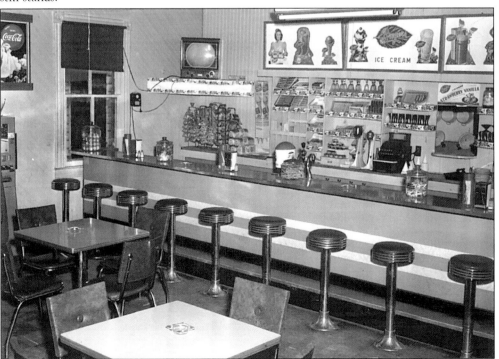

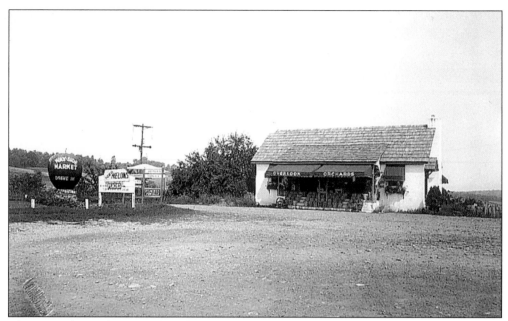

The Wayside Market was the place to get fresh produce west of Leesburg on Route 7. The building was demolished when Route 7 was widened and the "Big Apple" was put in storage. Many still remember the great cider, apples, and produce that could be bought at "The Big Apple."

Shown here is the old Leesburg Lime and Fuel Company on the outskirts of Leesburg, located along the W&OD Railroad.

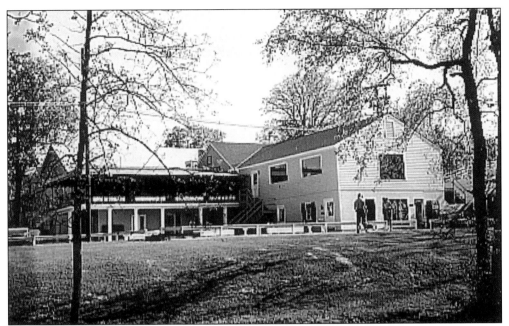

The Goose Creek Golf and Country Club was a favorite local establishment near Leesburg for many years. This is a view from the 19th hole in 1954 when construction was underway for a new addition. The building burned several years ago.

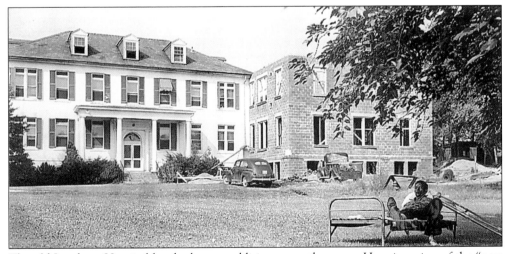

The old Loudoun Hospital has had many additions over the years. Here is a view of the "new wing" in 1949. Notice the patient outside enjoying the day.

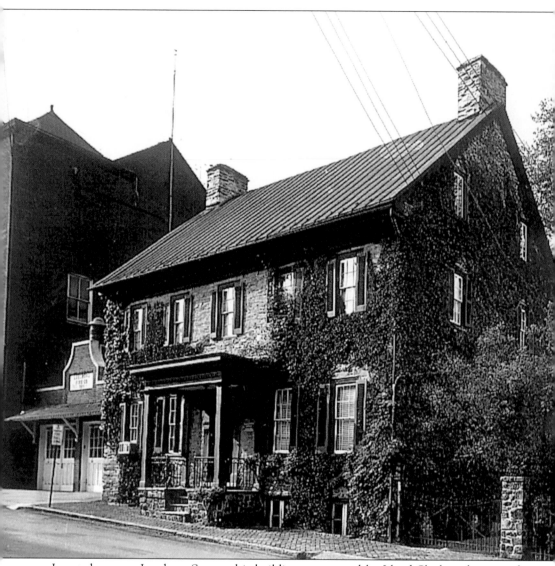

Located on east Loudoun Street, this building was owned by Lloyd Slack and operated as a funeral home from about 1909 until the 1950s. This photograph shows the building in 1954 after Lawrence Muse and Stanley Reed had bought the business. The building to the left was the old fire station and the larger building was the old Leesburg Opera House, where Belle Boyd spoke in the early 1900s. It was demolished in the late 1950s.

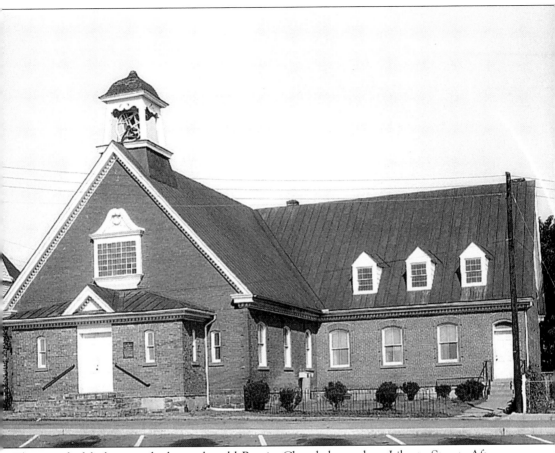

This wonderful photograph shows the old Baptist Church located on Liberty Street. After a new church was built the building was leased to several businesses, including the Department of Motor Vehicles, which was located in the basement. The old church has recently been renovated and is used as office space.

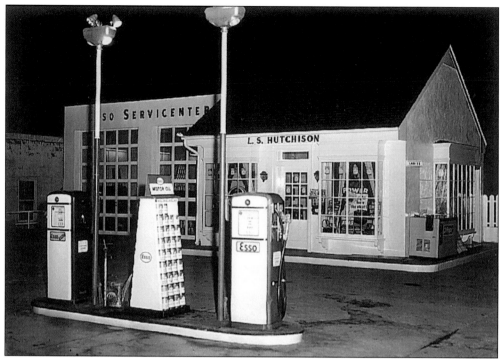

A 1950 photograph shows Lawrence Hutchison's ESSO Service Center on west Market Street. Today it is Jock Pumphrey's EXXON Service Center, a family-owned and operated business.

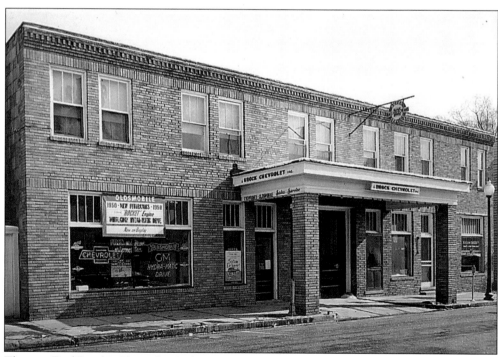

This was Fred Brock's Chevrolet dealership on Market Street in 1950. The big news in new cars in 1950 was General Motors' Hydra-Matic Drive.

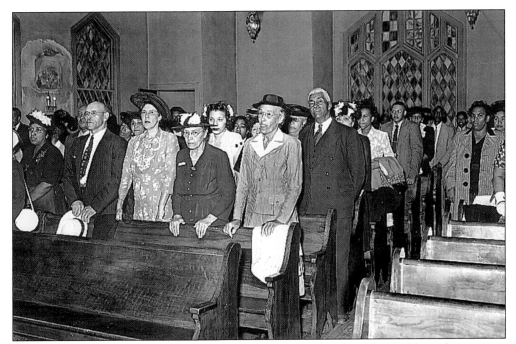

Mt. Zion Methodist Church, located on North Street in Leesburg, has held worship services for over 100 years. The building has been remodeled and expanded over the years to meet the ever-increasing needs of the congregation. This photograph shows the interior of the church and the beautiful stained-glass windows. Mt. Zion was an extension of the old stone Methodist Church just a few blocks away.

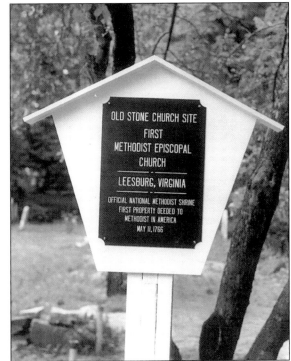

This photograph shows the marker at the old stone church site in the 1960s. The church site and cemetery have been preserved by the efforts of the Old Stone Church Foundation. A new wrought iron fence has recently replaced the chain-link fence around the cemetery.

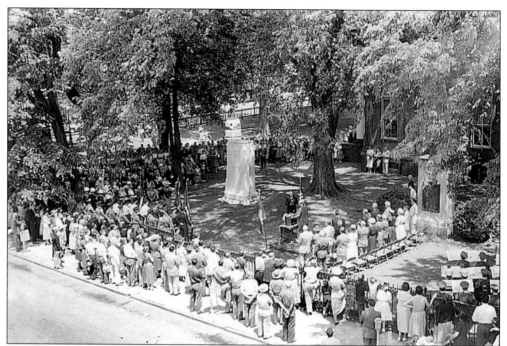

The courthouse lawn is crowded with people who have come for the dedication of the World War II Monument. Gatherings such as this at the courthouse have been a tradition since Colonial times when locals and their families would come to town in August, after much of the farm work was done, to shop, sell their products, visit, and watch court proceedings. This tradition continues today as the annual "August Court Days" celebration when re-enactors and venders fill the streets to recreate the spirit and fun of the old days.

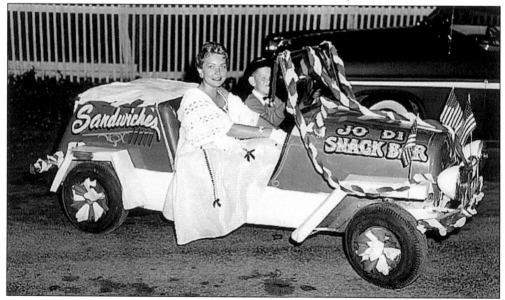

Everyone loves a parade. Here Mrs. Charles Brower drives her "sporty new car" in the Bicentennial parade in downtown Leesburg. Today a Fourth of July and Halloween parade are well attended by children of all ages.

This is the Leesburg Cities Service Center located on Loudoun Street. The building was used for several other businesses in and later demolished. The house in the foreground was moved to a different location around 1958.

This subdivision on west Market Street was one of the earlier ones in Leesburg. Built by Claude Honicon and called Honicon Court, the one-story stone houses face a central court yard.

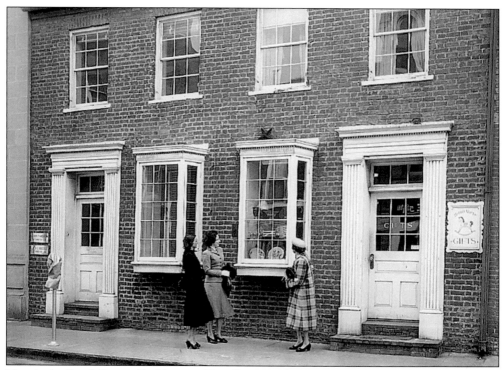

Here is the Frank Patton Building on King Street in downtown Leesburg in the 1960s.

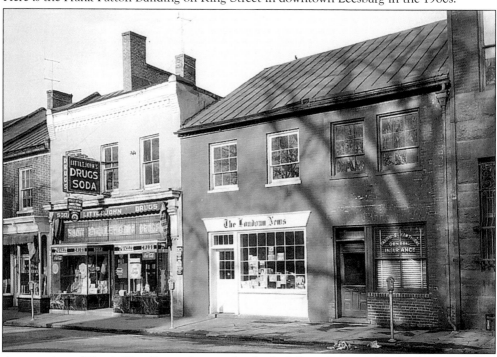

A great view of North King Street showing Littlejohn's Drug Store and Soda Shop, the office of the *Loudoun News*, Paxson and Hawthorn Insurance Co., and the corner of the Peoples National Bank, is seen here. The old Peoples Bank building today is the Lightfoot Restaurant.

This view shows the old Loudoun National Bank on the corner of King and Market Streets opposite the courthouse. The building today is the office of the newspaper *Leesburg Today*.

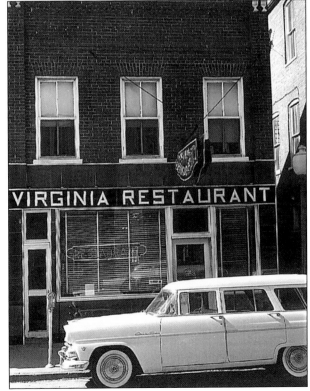

This is a view of the Virginia Restaurant on King Street in downtown Leesburg in 1960. The China King Restaurant now occupies the building.

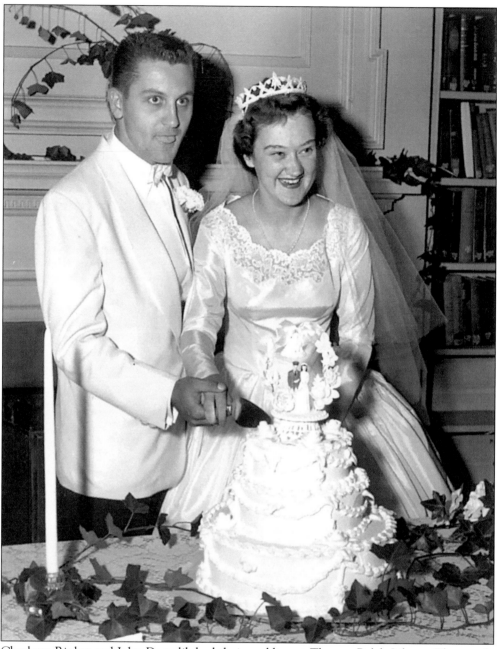

Charlotte Rinker and John Domalik had their wedding at Thomas Balch Library. The couple cut the wedding cake in the West Wing. They hope to celebrate their 50th anniversary at Balch Library in 2004.

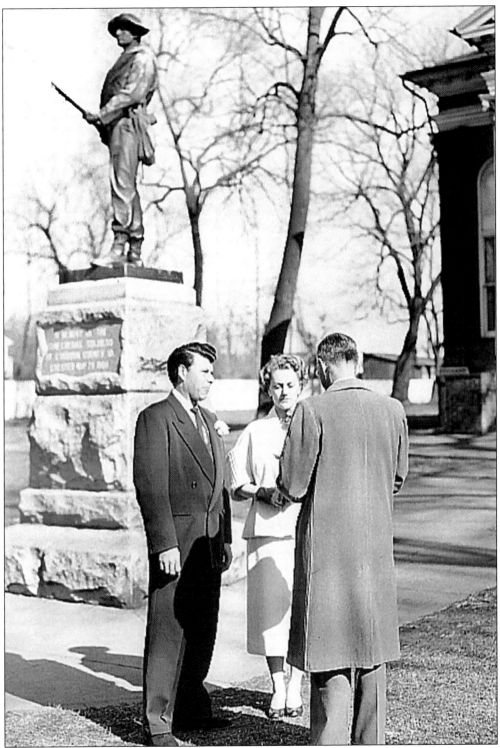

The courthouse lawn has always been the focal point of Leesburg. Here Max Davis and his wife take their marriage vows in front of the Confederate Monument on the lawn.

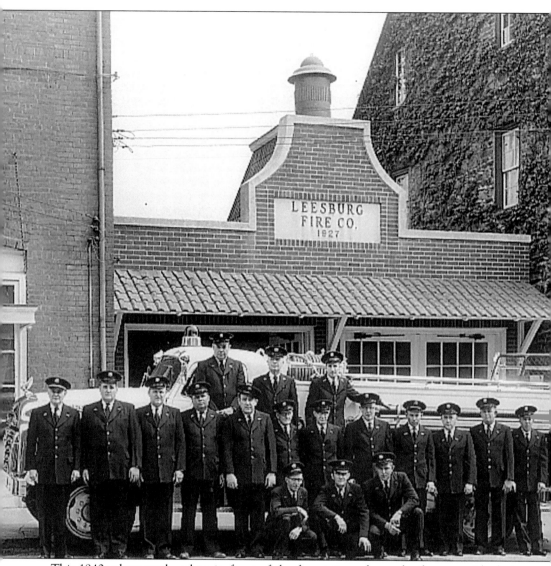

This 1940s photograph, taken in front of the fire station, shows the firemen with their new truck. Tom Donohoe (87), a fireman for over 50 years, identified most of the men in the picture. Those shown (but not in order) are Dave McDonald, Howard Gill, Jim Anderson, "AB" Titus, Wilbur Lloyd, Mr. Adrian, Jim Fleming, Howard Leigh, Jock Pumphrey, Harry Jenkins, Oden Semones, Tom Donohoe, Lewis Atwell, Everett Athey, Charles Thor, William George, Dude Moxley, Alfred Phillips, and Maloy Fishback. The fire company has since built a new station on west Loudoun Street and the old building is currently an art gallery.

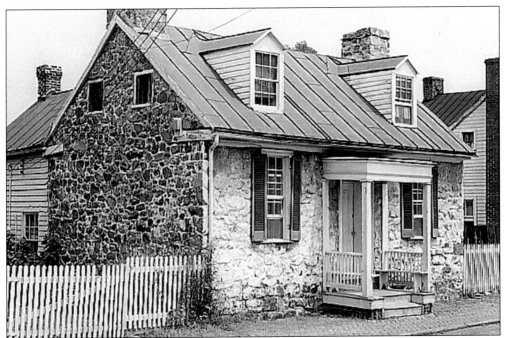

This building on Loudoun Street was for years called "Washington's Headquarters" even though it has since been proven to be incorrect—the house was never used by Washington. This wonderful old building is now the Stone House Tea Room, next door to the Norris House Bed and Breakfast. When this photograph was taken in the 1940s it was a private residence.

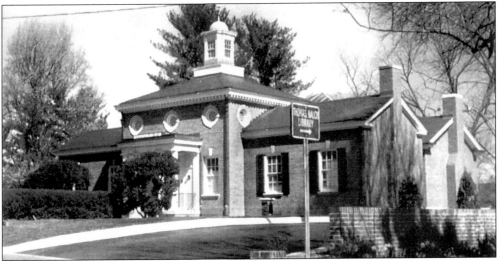

Thomas Balch Library was built in 1922 with funds from the Balch family in honor of Thomas Balch, who was born in Leesburg. Donations were given by citizens of Leesburg and Loudoun County. Originally a private subscription library, it became the main county library in the 1960s. When the new Rust Library was built in 1992 the county, no longer having a use for the old library, agreed to the purchase of the building by the Town of Leesburg. In 2000 an addition was built and the original building was renovated, keeping as much of the original structure as possible. In May 2001 Balch reopened as one of the premier local and regional history and genealogical libraries in the region. It is currently open to the public seven days a week.

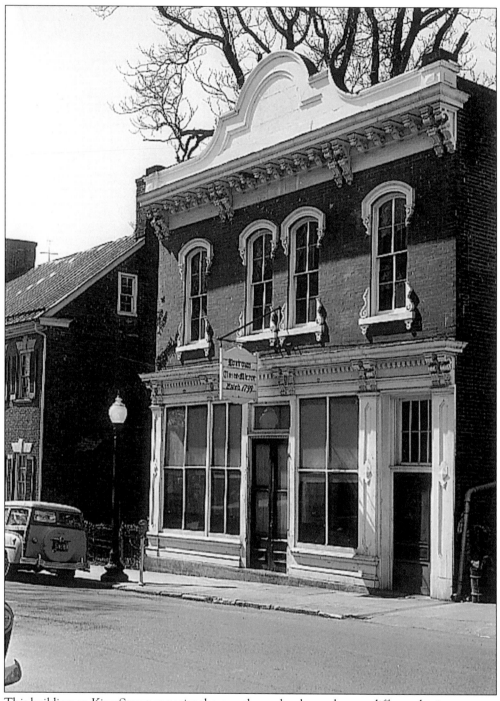

This building on King Street opposite the courthouse has housed many different businesses over the years. In the 1960s it was the home of the *Loudoun Times Mirror* newspaper. The *Loudoun Times* newspaper have had many names and owners since it started in 1799 in Leesburg.

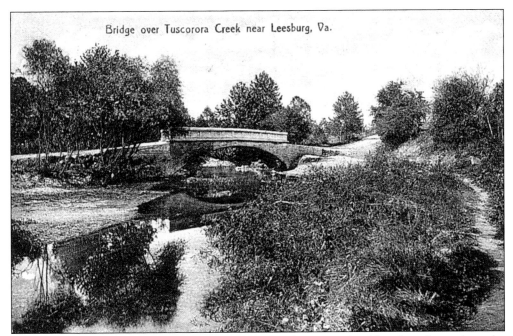

Bridge over Tuscorora Creek near Leesburg, Va.

This postcard shows the bridge over Tuscarora Creek just south of Leesburg located on the Izaak Walton League property. The property today is a community park owned by the Town of Leesburg.

This photograph is of the 150th anniversary celebration of the Presbyterian Church in Leesburg in 1954. As one of the older churches in Leesburg, there is a cemetery on two sides of the building with tombstones dating back to the early 1800s.

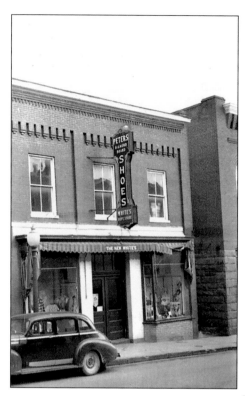

These photographs show White's Store on King Street in downtown Leesburg in the 1940s. A fire destroyed these along with some other buildings in the 1970s.

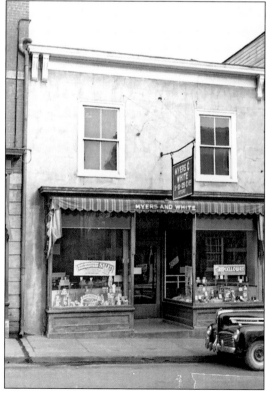

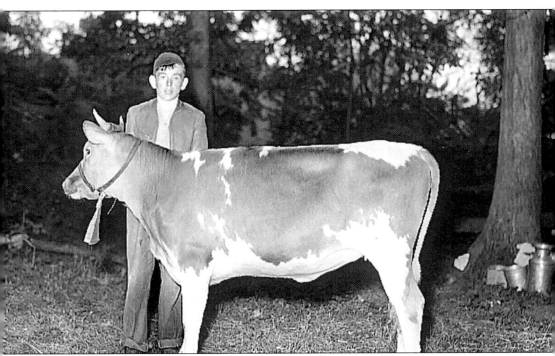

The 4 H Club Fair was a popular attraction in Loudoun County for many years. Here is Claude Bradshaw and his winning Grand Champion bull in 1947. Today with less agricultural influence and more population, the fair is known as the Loudoun County Fair.

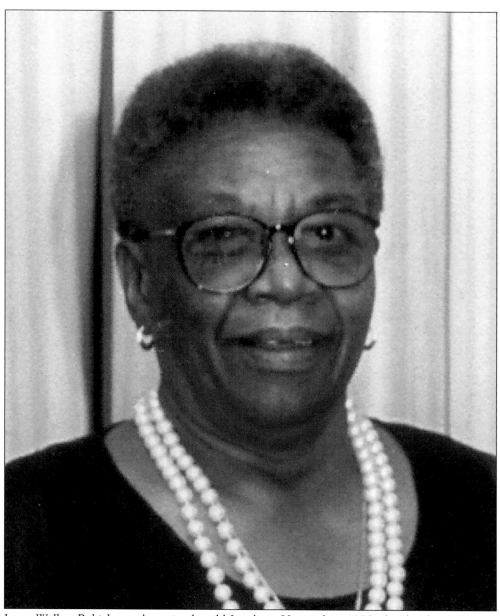
Irene Walker Bobich was born in the old Leesburg Hospital in 1935, the daughter of Laura Robinson and William Calvin Walker. Irene has been active in many civic organizations such as LARC, NAACP, the Women's Resource Center, and The Urban Civil Rights League to name a few. She has worked diligently as a commissioner with the Thomas Balch Library.

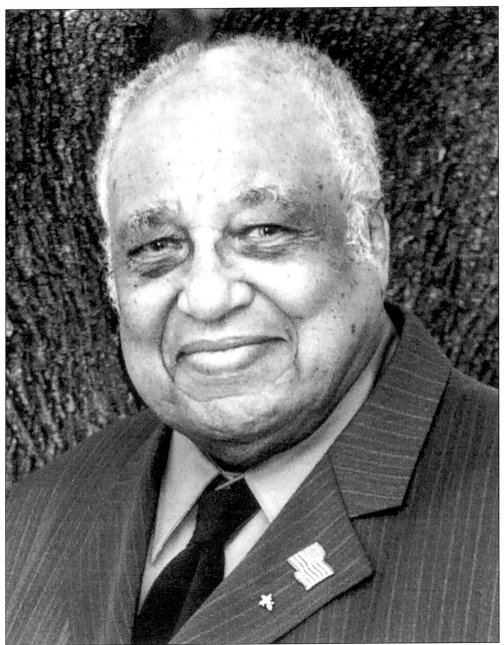

Wilson Townsend Jr. was born in Leesburg, the son of Wilson Townsend Sr. and Mossell Cooper. Wilson has had a variety of occupations over the years. He has worked on a farm, been a truck driver, a chauffeur, a bell hop at the Leesburg Inn, bottler at the Leesburg Coca Cola Plant, and night counselor at Graydon Manor, the position from which he retired. Wilson knows a lot about Leesburg and its history and is always willing to share his experiences of growing up in town. The Black History Committee of Thomas Balch Library recently honored Wilson. He still lives on Royal Street in downtown Leesburg.

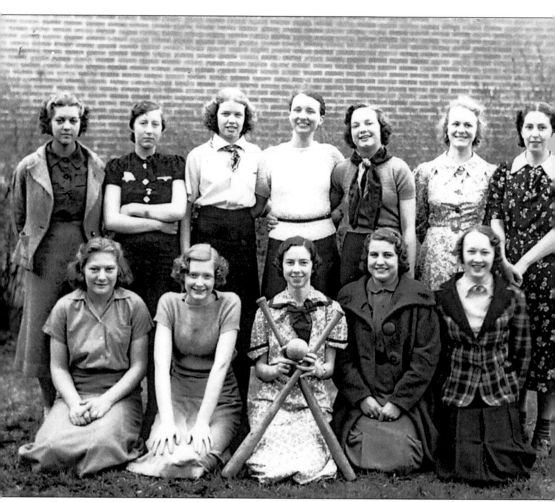

This is the Leesburg women's softball team in 1939. Pictured are Carrie Anna Fry, Christine D. James, Grace Jenkins, Rachel Arnold, Ola Church, Catherine McWilliams, and ? Simpson. The order of the identifications is not known and the names are listed as they appear on the back of the picture.

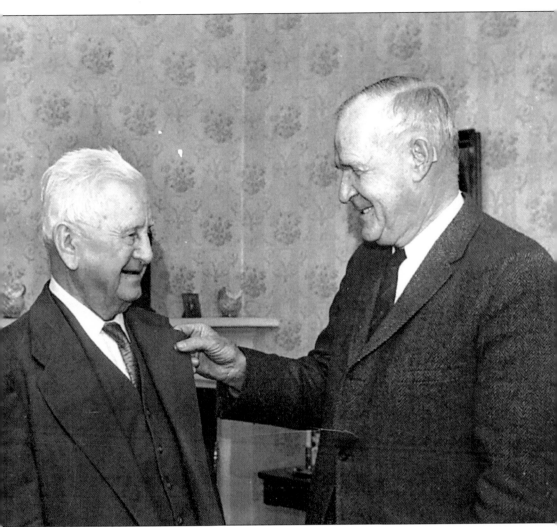

The Leesburg Hotel was used by many civic organizations for dinner meetings and special events. This 1950s picture shows Bruce McIntosh (left) and J.T. Hirst (right) at such a meeting. Active in the affairs of the towns of Leesburg and Purcellville and Loudoun County, Bruce McIntosh was president of the Peoples National Bank and J.T. Hirst owned the local lumber yard and hardware store.

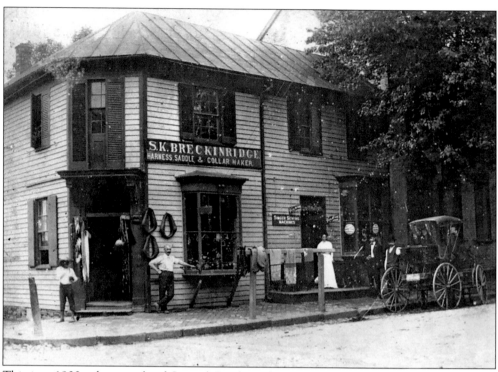

This is a 1900s photograph of Samuel Breckenridge's Harness, Saddle, and Collar Shop in Leesburg. Today businesses dealing with products and materials involving horses still enjoy a good business in areas of the county outside Leesburg.

This trailer load of melons met with a mishap on north King Street. The sheriff and driver gave free melons to whomever helped with the cleanup.

The Leesburg stockyards were a major part of the farm community in Loudoun County. Animals were brought here for shipping purposes and regular auctions were held for all kinds of animals including chickens, cows, sheep, pigs, ducks, turkeys, and even horses. The complex burned and was never rebuilt.

Spring and romance are in the air as this 1930s picture of Mary Frances Wiley and Landon Webb clearly shows.

This photograph is of "Miss Douglass High School" 1950.

This is a picture of Col. Armistead Thomson Mason Rust, who served in the Confederate Army and lived at the estate of Rockland near Leesburg. The Rust Archive at Thomas Balch Library bears his family name.

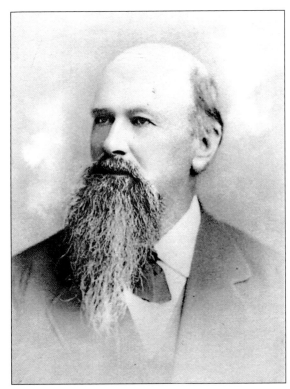

Ida Lee Rust, wife of Col. A.T.M. Rust, is noted for raising a large family in difficult times after the Civil War. Known as a woman of distinction in Leesburg, her diaries can be read at Balch Library. Ida Lee Park, which is owned and operated by the Town of Leesburg, is on land donated by the Rust family.

The Rust family has been prominent in Virginia and Leesburg for over 200 years. This lovely photograph is of Margaret DeHuff Meiley Rust, the wife of E.G. Rust, and her daughters Anne Elizabeth and Margaret Lee Rust. The Rust Archive contain a large collection of Rust family photographs.

Henrietta Lee Rust married this handsome gentleman, William M. Coulling. Many of the Rust women married military officers.

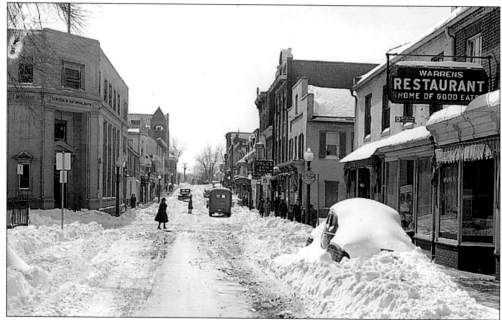

Downtown Leesburg hasn't changed much in the past 60 years. Snow still leaves the town in a mess for a few days. Warren's has changed hands and is now the Downtown Saloon Company, formally known as Payne's Biker Bar. Its motto, enscripted in a neon light, is "Better off here than across the street." Across the street is the county jail.

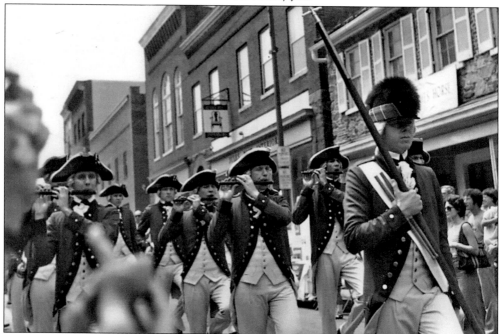

The third week in August from Friday evening until Sunday evening returns Leesburg to the 18th century with "August Court Days." Along with the stocks and dunking tank, re-enactors recreate colonial life and court proceedings on the courthouse lawn and the downtown streets of Leesburg. This event attracts over 30,000 visitors each year.

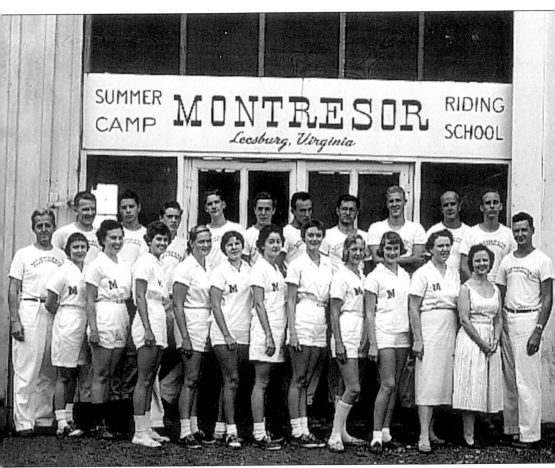

This is a 1960s photograph of the teens at Montresor Summer Camp and Riding School in Leesburg.

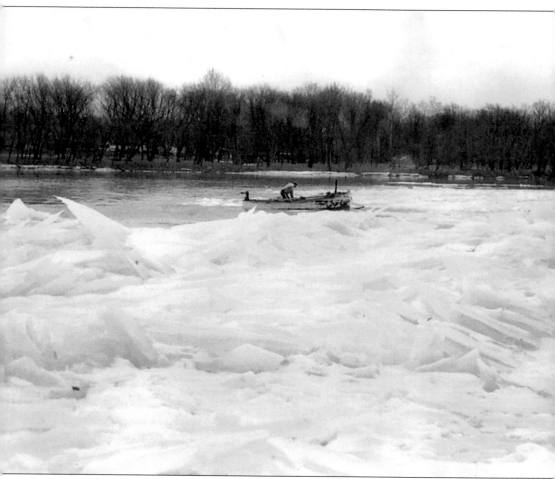

David Frye captured this scene on the Potomac River near Leesburg. This 1966 picture shows White's Ferry, a major commuter link between Maryland and Virginia, and the jagged ice that all but stopped river traffic for several days. Ice of this nature is unusual; it is usually high water that causes the ferry to close. (Photo by David Frye.)

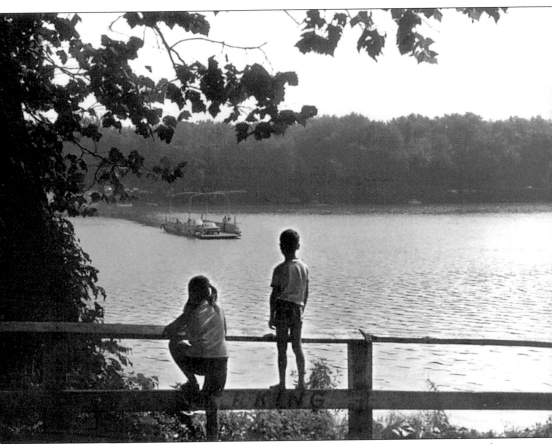

David Frye again captures White's Ferry, but this time on a lazy summer day. This timeless photograph shows children watching the ferry from the Virginia shore. The ferry, named the *General Jubal Early*, crosses the Potomac about every hour. Many of those who travel from Montgomery County, Maryland to Loudoun to work use the *General Early*, but it's also great for a pleasure ride across the Potomac River. Many families today picnic along the river and enjoy watching the *General Jubal Early* make its way across the river. (Photo by David Frye.)

ACKNOWLEDGMENTS

I wish to thank all the people who took pictures of Leesburg during the past 150 years. Without their photographs this book would not have been possible. My only hope is that my interpretations do them justice.

Special thanks to the following: John Fishback (my other half) for support, typing, and editing; Lee Catlett for scanning and technical advice on the photographs; LaVonne Markham for proofreading and editing; Jane Sullivan for allowing the use of the archives at Balch Library; David Frye for allowing me to view and print some of his wonderful collection of photographs; Frank Raflo for not only allowing the use of his photographs but for giving me some insight into history; Fran Poston, my best friend and photographer, who filled in some needed pictures; and the Town of Leesburg for having the foresight that was needed to allow Balch Library to remain the wonderful repository it is for Loudoun's history.